Legacies
of
Camelot

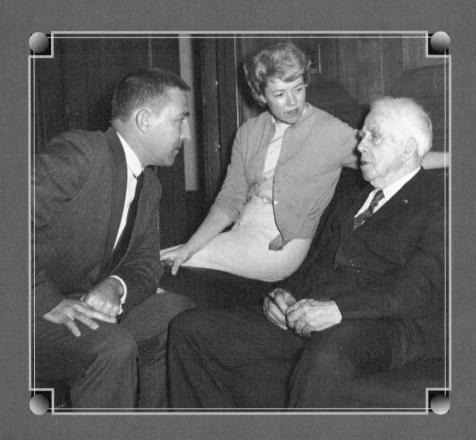

Stewart and Lee Udall in conversation with Robert Frost at the secretary's office on May 2, 1961. COURTESY STEWART UDALL.

Legacies of Camelot

Stewart and Lee Udall,
American Culture, and the Arts

L. BOYD FINCH

FOREWORD BY TOM UDALL

UNIVERSITY OF OKLAHOMA PRESS : NORMAN

Also by L. Boyd Finch

*Confederate Pathway to the Pacific: Major Sherod Hunter and
Arizona Territory, C.S.A.* (Tucson, 1996)
*A Southwestern Land Scam: The 1859 Report of the Mowry
City Association* (Tucson, 1990)

Library of Congress Cataloging-in-Publication Data

Finch, L. Boyd
 Legacies of Camelot : Stewart and Lee Udall, American culture, and
the arts / L. Boyd Finch ; Foreword by Tom Udall.
 p. cm.
 Includes bibliographical references and index.
 ISBN 978-0-8061-3879-4 (hardcover : alk. paper)
 1. Udall, Stewart L.—Art patronage. 2. Udall, Lee—Art patronage.
3. Cabinet officers—United States—Biography. 4. Cabinet officers'
spouses—United States—Biography. 5. Legislators—United
States—Biography. 6. United States—Cultural policy. 7. Arts and
society—United States—History—20th century. 8. Art and state—
United States—History—20th century. 9. Humanities—Government
policy—United States—History—20th century. 10. United States—
Intellectual life—20th century. I. Title.
 E840.8.U34F56 2007
 973.91—dc22 2007011042

The paper in this book meets the guidelines for permanence and durability
of the Committee on Production Guidelines for Book Longevity of the
Council on Library Resources. ∞

1 2 3 4 5 6 7 8 9 10

For Polly

She set the tone, aided the memories,
and often found just the right word.

Contents

Foreword

TOM UDALL

EVER SINCE THEODORE WHITE's classic interview with Jackie Kennedy a few weeks after the assassination, the legend of Camelot has been a symbol of the Kennedy years. During that interview, Mrs. Kennedy recalled a favorite line of her husband's from the popular Broadway musical: "one brief shining moment that was known as Camelot." Camelot has easily become our most compelling metaphor for recalling the vision and promise of the young president and his New Frontier as well as for the expansion of arts in public life that he and his wife promoted.

The Kennedy Center in Washington, D.C., is a lasting monument to Camelot and to a cultural tradition that began with Robert Frost at the Kennedy inauguration. Frost was invited to read a poem he had written for the occasion but could not do so because of the poor light. Instead he recited an old favorite, "The Gift Outright," and it was memorable. What may not be remembered is that the idea to invite Robert Frost in the first place was initiated by my parents, Kennedy's Interior Secretary Stewart Udall and his wife, Lee. With great charm and affection, this book chronicles how my parents introduced Robert Frost and so many other poets, artists, writers, and musicians into the cold halls of official Washington.

Personally, I think the best part of the story is that my parents—when they came to Washington from their small Mormon towns in the plain and rural West—were such unlikely ambassadors of culture. My father—one of six—was raised in the hardscrabble ranching community of St. Johns, Arizona. My mother—also one of six—was raised in Mesa, Arizona, by a widowed mother on workman's compensation. Neither had, growing up, the access to

culture one would associate with Camelot. And yet both had an instinctive and abiding passion for music, literature, and art.

The family likes to tell how my father, fresh from his Mormon mission in the East, including New York City, wooed my mother—and the competition for her hand was intense—by taking her to concerts and insisting they read poetry. My father prevailed, and their life together from the beginning was informed and infused with a joy and shared appreciation for the arts. Our lives—as children—were infused with the arts as well. Each of us was required to learn to play an instrument. Two of my siblings are now published poets.

Along with political figures and world leaders, guests in our home included poets and authors and artists and musicians. The children were always in the mix—perhaps because my parents did not have a staff and the children did the serving and clearing. My parents thrived on the combination of politics and culture. It would be, as Robert Frost wrote in "Dedication," the poem he wrote (but could not read) for the inauguration, "[a] golden age of poetry and power." I listened and learned.

When I came to Washington in 1999 as a freshman congressman from New Mexico, I was at a far different cultural place compared to where my parents had been. I had grown up exposed to cultural opportunities. I lived in Santa Fe, where I had all the advantages of access to the arts. Washington was different too. There were more poetry readings and concerts than I could ever attend. I did not—as my parents did—need to be the catalyst for introducing poetry into public life. I did not—as my parents did—have to create an artists' series to hear classical music in the capital's public buildings. We are now all beneficiaries of their efforts.

I am enormously proud that my parents had such an important role in defining what we know as America's Camelot. And I am very grateful to Boyd Finch for telling their part of that "brief and shining moment."

Preface

IN THE MID-1940S, Stewart Udall, Ermalee Webb, Polly Hagan, and I were students at the University of Arizona in Tucson. Of course, Polly, my future wife, and I knew who Stewart Udall was—the star guard on the university basketball team—but I do not recall that he and I ever spoke on campus. Polly knew Ermalee Webb, Stewart's future wife, slightly. After our graduation and marriage, Polly and I moved to California, where I received a master's degree from Stanford University in political science and worked as a reporter and copy editor on small daily newspapers. In 1955–56, we and our two young sons spent a year in Washington, D.C., when my editor in Ventura gave me a year's leave to work and learn "on the Hill" after I was selected as a Congressional Fellow of the American Political Science Association. Much of my congressional staff work involved western natural resource issues, and by immersion and with guided reading at the Library of Congress, I began learning how our national government worked. I served four-month stints on the staffs of Representative (later Senator) Lee Metcalf of Montana and Senator Richard Neuberger of Oregon, and six weeks on the national campaign staff of presidential candidate Adlai Stevenson before I returned to my California newspaper job. But, inevitably, I had succumbed to "Potomac Fever."

In 1960, at age thirty-five, I gained the Democratic U.S. congressional nomination in my California district and left newspaper work forever. The three-term Republican incumbent beat me, but my eight-month campaign expanded my acquaintance with party leaders. After the election I needed a job. With the new administration, there would be jobs in Washington, and in late December

1960 I headed east, temporarily leaving Polly and our boys in Ventura, where she was an elementary school teacher. Because of my efforts for the party ticket, Senator Clair Engle of California and Senator Metcalf of Montana opened the way for me to receive a White House interview that, in turn, led to an endorsement for an appointment in the natural resources field—Agriculture or Interior. During my congressional service with Metcalf in 1956, I had become acquainted with my fellow Arizona alumnus, Stewart Udall (at that time a freshman congressman), so I hoped that I might find a job somewhere—anywhere—in Udall's Interior Department. Nonetheless, it was a surprise when, in February 1961, I received an invitation to join Secretary Udall as a personal aide. I became the "confidential assistant to the secretary." My family joined me in the capital after the school year ended.

My duties soon included work on a Udall initiative not at all related to natural resource issues: the President's Cabinet Artist Series. It was something new, one of numerous arts activities outside the mainstream of Department of Interior functions that both Udalls would undertake during the coming eight years, and beyond.

Association with the visiting artists was a great learning experience for us Finches. Initially we were beyond our depth, for we were only marginally familiar with contemporary arts and artists. The Udalls' initiatives in the arts gave us opportunities for intimate views of cultural icons of the time—poets, writers, and musicians. Like the Udalls, we too were maturing. It was a singular time for us all.

After a year in which my desk was located in what was termed "the immediate office of the secretary," I was promoted to the staff of the assistant secretary for mineral resources, becoming the senior staff assistant for three successive presidential appointees. All the while, I remained in close contact with Stewart and his arts activities. Among other duties, my staff work with the cultural evening programs continued. Ironically, many of my duties with the assistant secretaries for mineral resources involved, not the West, but the Appalachian region, where I studied ways to deal with the human costs and land and water resource damage resulting from underground and surface coal mining. Ultimately I became Interior's leadoff witness on a Senate bill to regulate strip mining, describing the problems in words and with slide photographs. Secretary Udall followed with testimony supporting legislation to begin remedying the situation.

We Finches enjoyed our decade in Washington—years on the fringes of power. In 1971 I moved from Interior's minerals activities to the National Park Service. There I served as associate regional director for planning and preservation, covering eight southeastern states, Puerto Rico, and the Virgin Islands, with my base in Atlanta. Contact with the Udalls ceased until after my early retirement and our return in 1981 to Arizona, where Polly and I saw Stewart occasionally. We suggested to him that the Udall contributions to the arts and humanities deserved to be recorded; he seemed interested but never followed through. Then, in November 2002, he phoned from his Santa Fe home, inviting us to breakfast at Tucson's Arizona Inn resort on a forthcoming Sunday. There he handed us two bulging bundles of papers about the Udalls and Robert Frost. It was a beginning.

Since then, drawing on our recollections and memorabilia, with the continuing help of Stewart by means of personal visits, mail, and many telephone calls; the generous assistance of numerous Udall friends and associates; plus the more than 240 archival boxes of Udall papers at the University of Arizona Special Collections Library, we have assembled the following account. It is history, and it is important. With the exception of Udall himself, I may be the only person living who can tell much of this story—because I was there. In the telling I have included occasional mention of Finch participation and reactions, but the subject is the Udalls and the arts—not the Finches.

I applaud what Stewart and Lee accomplished in the arts, but I do not intend that this account become a hagiography. My purpose is simple: although I have been away from journalism for many, many years, I could not let a good story go unreported.

Legacies
of
Camelot

Introduction

It was "an overwhelming surprise" to Lee and Stewart Udall when Robert Frost accepted their invitation to dinner in May 1959, but it was no surprise to Arizonans less than five years earlier when Stewart first won election to Congress.

Politics runs in the Udall family. They're good at it. Within the lifetime of many persons living today there have been four Udalls in the Congress, at least three Udall judges, a state attorney general, a chief justice of a state supreme court, one presidential cabinet officer, and even a serious candidate for presidential nomination. After winning four elections to Congress, Stewart became the first Arizonan to serve in the cabinet, and his appointment as Secretary of the Interior was the first cabinet selection announced by President-elect John F. Kennedy in 1960.

It certainly could not have been foreseen that Stewart would become an intimate of leading American poets, would initiate precedent-setting cultural events, help create landmark performance halls, and become the author of a book-bag-full of serious nonfiction works.

Perhaps even less predictable were the accomplishments of Ermalee Webb, a small-town girl whose mother maintained her brood of six after the accidental death of the young husband and father. In college, Ermalee and Stewart fell in love and married. Stewart's election to Congress sent them to Washington, D.C., where she—known as Lee Udall—advanced the arts education of American Indians, became an authority on the preservation of traditional American folk arts, and—far less significant but still remarkable—hosted the queen of a Middle Eastern nation on the afterdeck of the presidential yacht. For Stewart and Lee Udall this

is a story of growth as emphasized by their activities in the arts and humanities—personal growth that created legacies for the nation.

The brief years of the Kennedy administration have come to be remembered as a mythical "Camelot," when a young president and a crusty old poet brought forth a bright mood that valued the arts. As the Fates would have it, Stewart and Lee Udall helped create that mood. It was a far journey from their origins. And, through it all, they raised six children. It should be remembered, moreover, that during the quarter-century that the Udalls lived in the capital, national affairs were in ferment. There were many distractions: the Cold War; the Montgomery Alabama bus boycott and Freedom Marches; the beginning of the Interstate Highway System; the Cuban missile crisis; the assassinations of President Kennedy, his brother Robert, and Martin Luther King; the passage of civil rights legislation; escalation of the Vietnam War; *Roe v. Wade*; the Apollo mission to the moon; the "normalization" of China relations; Watergate and President Nixon's resignation.

Stewart and Lee were involved only peripherally in many of those milestone events, but during Stewart's eight years as Secretary of the Interior, four national parks; six national monuments; seventeen assorted seashores, lakeshores, and recreation areas; twenty historic sites; and fifty-six wildlife refuges were added to the national heritage. He participated in legislation that resulted in the Wilderness Act, the Wild and Scenic Rivers and National Trails Acts, the Land and Water Conservation Fund, the Central Arizona water project, and the Historic Preservation Act. As landlord of the new District of Columbia stadium, he helped persuade the reluctant owner of the Washington Redskins to integrate the football team.

All that and more should be told in detail by some future biographer. What might otherwise escape notice, however, is how the two Udalls strengthened America's recognition of the arts and, in so doing, grew from self-labeled "hicks" to noteworthy figures in the nation's cultural life.

The stage was set, although they could not have known it, when Stewart and Lee Udall and their (then) four young children arrived in Washington in January 1955 to begin Stewart's first term as a member of Congress from Arizona. They returned to their native Southwest twenty-five years later. Much had happened in America's arts world during that quarter-century, and the Udalls were at the center of the cultural advances achieved in those years that encompassed all or part of six presidential administrations. In

1955 there was no Wolf Trap Farm Park for the Performing Arts, no Kennedy Center or annual Kennedy Center Honors, no Institute of American Indian Arts, no National Endowments for the Arts or for the Humanities. The nation had no poet laureate. All but forgotten, Ford's Theatre had been dark since the night in April 1865 when Lincoln was assassinated. There was no gallery in the capital devoted to the arts of America's Native peoples. In addition to promoting Indian art, Lee found a role in preserving American folk arts and culture.

Hints of change could be detected even in the late 1950s, but the pace quickened in the sixties with the inauguration of John F. Kennedy, and the momentum continued through the terms of several succeeding presidents. Most especially, the Kennedy and Johnson administrations fostered a growth of appreciation for American poets, an awareness of the cultural diversity and creativity of American Indians, and a dawning of the national government's promotion of American arts and humanities. Initially surprising to some observers in the capital, Stewart and Lee Udall contributed materially to those developments.

The Udalls' interest in the arts began in the Southwest, flourished during eight cabinet years, and continued to thrive during their postcabinet decades in Washington and the West. In no way should the Udalls solely be credited with that tide of change that swept over America, but they left an imprint on our nation's culture, and an account of their accomplishments in the arts is essential if the entire story of Stewart and Lee Udall is to be preserved.

Chapter 1

A Country Boy, a Small-Town Girl

"TWO YOUNG PERSONS from the rural West brought the arts to Washington." When Stewart Udall is in an expansive mood that's how he tells it. In another recent conversation, as he reflected on the arts movement that he and his wife, Lee, initiated, Stewart suggested, "We provided a kind of background music." That may be too modest.[1]

This is a narrative of the growth of a country boy and a small-town girl out of the desert Southwest who helped ignite change in the nation's arts and humanities. This story is as true as most stories are, as true as my honest effort and decades-old memories can make it. Much is involved in the telling: literature—poetry most of all—history, drama, music and dance, sculpture, architecture and design, even some wisps of philosophy. And, politics. Many scenes are involved: long white gloves and a tuxedo green with age, a poet who couldn't read his newest poem, a hasty eviction at a rustic restaurant, Frank Lloyd Wright in absentia, and Mark Twain in person, almost. There is a banquet at which the honoree rose to speak at six minutes after midnight, and a small dinner party that was followed by . . . well, you'll have to wait awhile to learn about that.

Stewart Udall is an old warrior now, one of two survivors of the cabinet that President John F. Kennedy appointed in 1961 (Robert McNamara is the other). Secretaries of the Interior usually create slight impact on the national scene, but Udall proved to be different—young, vigorous, aggressive, a political hardball player, the only member of the cabinet whose home was the West. There was—*is*—much more to him, however, and it is this other aspect of his life, and that of his late wife, Lee, that are recounted here. As the *New York Post* observed when his appointment was announced

by Kennedy, Stewart Udall is "a happy cross-breed of Western outdoors-man and Eastern-style intellectual." Even admirers of Stewart's advocacy of environmental and American Indian causes may remain unaware of his artistic, poetic, intellectual depths. Poets and poetry are especially important to him. Music, too. And he wants to create a better understanding of the broad dimensions of the culture of the American West. After initial coaching from top-notch writers, he developed into a skilled author of fifteen books in thirty-nine years.[2]

In Lee Udall there were depths also. She was an imaginative organizer and a persuasive leader with a mischievous sense of humor. In Washington and beyond, she spread appreciation of the graphic and performing arts of American Indians, playing a major role in developing the Institute of American Indian Arts in Santa Fe. Further, she became a national presence in the movement to preserve America's varied folklife—songs, dance, art, tales, crafts. Some quality in Lee endeared her to persons of diverse backgrounds. Her memory is enshrined in a northern Plains Indians love song and in a Kiowa prayer. A cowboy folksinger found her to be "the greatest thing since sliced bread."[3]

Both Udalls descended from Arizona pioneer Mormons (Church of Jesus Christ of Latter-day Saints). Stewart is a native of St. Johns, a windswept county seat on the mile-high Colorado Plateau of northeastern Arizona, nearer to Apache, Hopi, Navajo, and Zuni reservations than to the state capital at Phoenix. St. Johns's population hovered around three thousand. In Stewart's youth, Mormons of northern European ancestry settled on one side of town and Spanish-speaking Catholics lived on the other side. The Little Colorado River borders St. Johns, providing minimal water for irrigation. It is hardscrabble country. Levi Udall, Stewart's father and the county's judge, also tended a 160-acre farm near town and was a regional leader of his faith; a judge's salary made the Udalls "well off" by local standards. Levi and wife Louise produced three daughters and three sons. Both parents were persons of ability. Levi was a leader in public affairs as well as in church activities. Louise was a woman of talent: she wrote an unpublished article on the Mormon settling of northern Arizona and, many years later, coauthored the biography of a Hopi woman friend, *Me and Mine: The Life Story of Helen Sekaquaptewa as told to Louise Udall.*[4]

Stewart once observed, "Modern civilization rode a slow horse to St. Johns." The town had no bank, no railroad. When he was born, January 31, 1920, the

family lived in a vertical-plank-walled structure built in 1885, so drafty that on windy days the Sears Roebuck rug would rise like a bubble in the middle of the room. Mother Louise called the house her "air castle" and she didn't like it. Two years after Stewart's birth, at her insistence, the Udalls moved into a new bungalow that had running water, but an outdoor privy.

When Stewart, the eldest son, and Morris ("Mo"), two years younger, were old enough, they helped butcher the hogs, trimmed each other's hair, built a rock wall, and milked the cows. "Frugality was built into our lives," Stewart says. Many evenings, all sang as Louise played the piano. Stewart happily discovered that an Albuquerque radio station broadcast classical music once a week. He bought a paperback book of American poetry and memorized verses and, in his words, "an inordinate love of poetry and history" became a part of his life.

For the Udalls, kerosene lamps made do into the 1930s. Even after electric service began, St. Johns's went off at 10:00 P.M., so Stewart would "read like mad" until the lights flickered off, and then he would continue by the light of an oil lamp. He later likened life in St. Johns to that of a small town in the nineteenth century, and he deemed that his "good fortune." Brother Mo once remarked that "Stew always was reading something new, getting into a new philosophy, a new field." Stewart learned that in 1540—generations before Jamestown and Plymouth—the expedition of Spaniard Vásquez de Coronado passed through St. Johns country in search of Cibola, "the seven cities of gold." He remembered that.

What was there that led to Stewart's love of poetry and music? There is no simple answer to the question, but some clues may be found in the Mormon culture of his youth (and in Lee's youth as well). Music is an inseparable part of the Mormon religion. During the church's earliest days in the valley of the Great Salt Lake the faithful built their acoustically marvelous tabernacle, for many years the site of weekly broadcasts by the famed Tabernacle Choir and Orchestra, as well as special television presentations. Singing became a staple of Mormon "family nights." Stewart's mother—the family's "creative one," he says—wrote plays and pageants for the St. Johns community, and he remembers an outdoor Easter production of hers in which he had the starring role. A St. Johns high school teacher introduced Stewart to the works of composer Frederick Delius; she lent her student phonograph records of Delius compositions (by then the Udalls had a record player).

In addition to his anthology of American poetry, Stewart remembers two other collections of poetry on the family bookshelf, along with many "church books." And his mother was not the only author in the family; Aunt Pearl Udall Nelson compiled and edited a biography of Stewart's grandfather, the pioneer settler of St. Johns.[5]

As a boy, Stewart was an organizer. When youngsters held a mock trial in the Udall garage, he was the judge. As a show business promoter, Stewart organized a kids' rodeo with events utilizing calves, sheep, and bicycles. He charged small entry fees for each event, awarded prizes, and ended the day with a four-cent profit. He played every high school sport available and won "All-State" honors as a halfback. After high school, he lettered in basketball at Gila Valley Junior College in Thatcher, another small Mormon village, and at the University of Arizona in Tucson.

On a return visit to the university in 1965, Secretary Udall remembered "coming here as a very young man from what you would call a 'part of the sticks' . . . and the awe with which I approached this university." The required Survey of the Humanities course for sophomores (which Lee also took) "marked a turning point in my formal education . . . [it] transmitted to me a love of learning and a respect for the great ideas of the past." For two semesters he attended weekly group lectures and small reading-discussion groups. The survey course included samples of Western culture from ancient times to modern: snippets of Homer, the Bible, Plato, Virgil, Chaucer, Dante, Shakespeare, Descartes, Milton, Goethe, Marx, Dostoevsky, and many other thinkers and writers. Students listened to and discussed recordings of music from medieval sources to contemporary composers. Photos and illustrations of art from the Greeks to the mid-twentieth century were analyzed. Stewart still pays homage to that course: "It was vital to me."[6]

In 1940 Stewart left the university for a two-year Mormon mission, much of it spent in New York City where "I attended all the Broadway plays," buying tickets for forty-five cents. At the opera and concerts he paid the minimum for standing-room tickets in the rear. When his church mission in the East ended, Stewart joined the Army Air Corps and became a waist gunner on B-24 bombers.

Before going overseas, he left his parents a typed page: "This is not a will, but merely an expression of my wishes and desires should next months see my death. . . . I love music and poetry, and would prefer that they dominate

any service that might be held in my memory. In the world of music I loved DeBussy [*sic*], Delius and Sibelius, and would with time have treasured Beethoven and Bach. Among the poets I preferred above all [are] Shakespeare, and Frost, Yeats, Shelly [*sic*], Keats and Wordsworth. . . . Let the afternoon of my memorial be devoted to the contemplation of beauty."[7]

He flew more than thirty-five missions. Between the bombing raids Stewart wrote poetry, and one of what he called his "bombs away" verses was published in the servicemen's newspaper, *Stars and Stripes*:

Target Time

Flung forth from those swirling, sooty puffs are seeds of death.
Hope on fate, airmen, no gallantry here against a hidden foe;
Crouch low—grim, silent, apprehensive and alone.
Await what comes; prepare to die—or live—or leap.
Your hour has come—the earthward lurch, flaming wake,
 disintegrating roar—
A noon-comet courses the mid-day glare.
Searing the mid-day sun.
A pang of terror—your first and last (no sooner felt than passed!)
They are no more who knew these clouds;
No cross or cenotaph can be erected here.
But searchers of the sky may see, traced clean and clear
A vapor trail against the blue; a veil to mark their bier.[8]

On his return from Europe, Stewart typed a five-page testament, a statement of principles: "Compiled on the Completion of a War." He seasoned his "compass points" with quotations from von Clausewitz, T. E. Lawrence, and Antoine de Saint Exupéry: "I consider it necessary to distinguish *my* [underlined in the original] attitude from that sentimental thinking which confuses itself in vague statement about 'our responsibilities to the honored dead. . . .' The fallen were many-minded, and it is probable, had they lived, that many would be indifferent, others would oppose, and some few would perhaps have applauded, whatever personal 'program' I, as one individual, might now essay. . . . [T]herefore, in being true to myself—in refusing to compromise the point of view of my group—I can act with some sureness of discharging a 'responsibility.' And so it is with each man."[9]

Ermalee Webb was born in Phoenix on May 22, 1922. Her father, Lee, died in an explosion while he was a foreman on a canal construction job when she was five. After that, Ermalee preferred to be called Lee. Following her father's death, her mother, Lillie, moved herself and her children to a little adobe house on an unpaved street in Mesa, population then about seven thousand, bordered by cotton fields and orange groves in the Salt River Valley of central Arizona. Like St. Johns, Mesa was founded by Mormons, and it remained predominantly Mormon in the 1920s and 1930s when Lee was a child. In 1927 it became the site of an LDS temple, the seventh in the world, an indication of the area's importance to the Mormon Church.

Lillie raised three sons and three daughters (Lee was next to youngest) on workman's compensation, some help from their church, and whatever the children could earn. Lee related that "we all picked cotton," sold fireworks for the Fourth, and with a child's wagon, peddled cantaloupe "culls" from a packing house "at two for a nickle." But with the workmen's compensation checks each month, "We never felt poor."[10]

When she was a kindergartner, a playmate cousin fell ill with polio (then called infantile paralysis). Lee took sick two weeks later. Both girls lost the use of their legs, and the cousin was crippled for life. Lillie would not let that be Lee's fate. Years later, while discussing the polio, Lee said, "My mother was incredible . . . intuitive." Without any physician's guidance Lillie applied hot packs to Lee's legs, followed by icy cold packs; she believed that increased blood circulation was essential for full recovery. Then she made her small daughter crawl on the carpet ("pull yourself by your arms and push with your toes") from the bedroom toward the kitchen, going a bit farther each time, until no sign of the potentially crippling handicap remained.

To escape some of the summer heat, her mother packed the Webb brood in their Ford and drove north to tiny Pinedale, elevation more than sixty-four hundred feet, in Arizona's ponderosa pine forest. There among aunts, uncles, and many cousins, Lee explored the forest and her Grandmother Webb's bookshelves. She cherished her grandmother as "a lover of poetry and literature." Many years later, Lee recalled that at Pinedale "evenings were filled with 'home-made' entertainment. Often there would be 'a family fireside' evening, where young and old gathered to sing, pop corn, or pull taffy." Sometimes it was a "social" at the church, where even the youngest child was allowed to stay up and watch the dancers. "I accepted my first

invitation to dance [there]. . . . My partner was my uncle and I was six years old."[11]

Indian reservations were close by Mesa, and as Lee grew older she attended tribal festivals. Half an hour distant was Phoenix (population nearing fifty thousand) where Indian women, seated in front of Woolworth's, sold their unique creations—baskets, pots, and jewelry—such as still occurs at the plaza in Santa Fe. Stewart says that Mesa had excellent schools and that Lee read good books; a friend once described her as "a voracious reader." In Mesa High School a once-a-week assembly program encouraged student performances. Along with four or five boys and girls, "the acting troupe of the school," Lee helped write and produce skits for the stage. After high school, Lee attended Arizona State College in nearby Tempe for a year. Then during World War II, she worked fifty hours a week in an office at Northrop Aircraft's factory in Inglewood, California, and also found time to take two night courses at UCLA. At war's end she returned to Arizona and enrolled at the university at Tucson.[12]

After receiving his undergraduate degree, Stewart returned to the University of Arizona for more basketball and a law degree. He displayed a curiosity about words. Tucson's morning newspaper conducted a vocabulary contest among university students, requiring definitions of fifty seldom-used words; Stewart was the winner. When the basketball team played in the National Invitational Tournament at Madison Square Garden (a first for the school), he sent back dispatches as the team traveled cross-country by train, only to lose its first-round game to the University of Kentucky. Morley Fox, a columnist for the student newspaper, described the point guard as "quiet, gentlemanly . . . with a smile he cannot hide," and as "a devotee of classical music." Stewart was "fascinated" by the performances provided by the university's modest Artist Series, programs free to students and open to Tucson townfolk for a small charge. Polly and I remember that programs during one year included appearances by operatic soprano Lotte Lehmann, Mexican vocalist Tito Guizar, the touring National Opera Company, and yes, a concert by "Pinky" Tomlin's traveling dance band. Stewart also remembers "the daring language" in a road company presentation of Erskine Caldwell's *Tobacco Road*, at Tucson's unique Temple of Music and Art.

The scholar-athlete followed family tradition in his interest in politics, writing about political issues for newspapers in St. Johns and Holbrook.

Mormons commonly have large families, and the political allegiances of the state's many Udalls range across the spectrum. Not all are Democrats. Stewart campaigned in vain against a state "Right-to-Work" proposal; in that same year, 1946, his father won election to the Arizona Supreme Court, ultimately serving as chief justice.

Lee met Stewart on campus after she "shattered a leg" in a motor scooter accident. The diathermy machine operator at the campus infirmary was Stewart, a part-time employee while in law school. They married before he received his law degree. Even in school they were "two extraordinary people," according to a fellow coed and lifelong friend, Martha ("Martie") Proctor Barry.[13]

Stewart and brother Mo (also a basketball player and law student) led a successful effort to integrate the university's eating place, and later they helped found the Tucson Council for Civic Unity, persuading the owner of a local drugstore chain to open his lunch counters to blacks. Stewart organized Tucson's Chamber Music Society, which thrives still, and he presided over a school board. Family connections, Democratic activities, and his law practice provided contacts across the state.

Arizona's postwar boom was in its earliest stages. Tucson, expanding toward fifty thousand population, was the largest community in the mostly small-town and rural Second Congressional District that stretched from Utah and Nevada to the border of Mexico, excluding only Phoenix and its suburbs. In 1954 it was an "open seat," and Stewart saw an opportunity. His election was not a foregone conclusion. Republicans were gaining in the state, and not everyone looked on Udall favorably. There are Arizonans today who say frankly, "I didn't like him," and still hold that view. But soon a newly elected freshman congressman, with his wife and their four children—the eldest six years old—left Tucson in a jam-packed Ford station wagon, headed for the nation's capital. The arrival of yet another freshman congressman and his wife and small children from a sparsely populated southwestern state was scarcely noticed.[14]

Chapter 2 ────────────────────────────

The Poet Comes to Dinner

THE UDALLS WERE NOT FULLY PREPARED for what they found in Washington. Soon after their January 1955 arrival, Lee revealed their naïveté in a letter to her mother. The couple had been invited to a 9:00 P.M. reception at the Eisenhower White House:

> We found out that nobody ever appears at the White House after dark in anything but formal attire. Since we were both outfitted with what we considered formal, we were perfectly at ease about it all ... until yesterday afternoon when Della, my friend who's working with the staff, heard about it and told Stewart he had to wear white tie and tails. We about decided to not go, but they all convinced us it was worth renting tails ... so he did. Well, then at 4:30 she called me to say that I must absolutely wear formal evening gloves. I just laughed and said I had some nice little gloves which went with my short formal and Della said oh, you can't possibly wear a short formal to the White House. Well, then for an hour they phoned around to find out whether or not I could wear a short formal to the White House and Mrs. Benson [Mrs. Ezra Taft Benson, wife of the Mormon agriculture secretary] finally decided that since I am a comparatively young person perhaps I could get away with it *once* but that I must absolutely have long gloves. So ... Stew came home early and I dashed 15 miles to buy a pair of formal gloves (white by all means!). We had dinner and sort of waited around nervously until 8:00, when we started getting ready ... and from then on it was really a comedy of errors. Stew forgot that they had given him special studs and links to go with the stiff shirt

and collar, and I labored for 30 minutes and practically tore his neck to shreds trying to get him into the thing with regular studs. Finally he remembered the ones that came with the rented garb, and after another 30 minutes we managed to get him dressed. I jumped into my things and we were off.

We had received a card for admittance to the grounds, so, like freshmen, instead of parking our dirty old car on the road and walking in as did everybody else, we followed a cab right up to the front door and when my door was swept open, I almost fell out, as did three bottles with sour milk in them and a dirty diaper as well as several other miscellaneous items. They ushered Stew—in the dirty wagon—out the gate and I went into a reception room to wait for him. I was not the only woman in a short gown and Stew was not the only man whose neck was too big to hide the clip on his tie . . . and Ike and Mamie are very handsome charming people . . . we just shook their hands, and we scooted on through to fruit punch and goodies and then to a dance hall with a band. We met Mr. and Mrs. Benson and they spoke very nice words about our parents and Bro. Benson did not pass up the opportunity [to] give us a little sermon.

Now, Mother, . . . we don't want the general public to know what hicks we are. . . . Keep [this] to yourself.[1]

Stewart and Lee became more comfortable in their eastern surroundings, buying a house at 1169 Crest Lane in McLean, Virginia, close commuting to Washington. The house was of contemporary design, ringed by trees. In front it resembled a one-story "ranch house," but that was deceptive. The house rested on the crest of a bluff above the Potomac; in the rear it was two stories. Through the woods beyond, the rumble from Little Falls Gorge provided background sound. There was room for more kids; a fifth child, their third son, arrived in 1956, and Lee was pregnant again in 1959. The Udall home—not a large residence designed for formal entertaining—was more in the *Ozzie and Harriet* or *The Brady Bunch* mode for kids and pets. Nonetheless, it became the setting for a transformation of the Udalls' lives, and they adapted well. They collected southwestern art—pottery, paintings, carvings—which ultimately led the *Washington Post* to state, "The Udall Home is a Museum of Indian Art."[2]

Over time, the Udalls made their Crest Lane home a meeting place for literary folk and politicians, plus an ambassador or two. Friendships would

bloom with literary persons—poets Robert Frost and Robert Lowell; editor-historian Alvin M. Josephy, Jr.; Pulitzer Prize–winning author Wallace Stegner; world-traveled journalist turned painter William ("Bill") Walton; novelist-historian David Lavender; and publisher Gilbert Harrison. Beyond that assemblage, the Udalls moved into a world inhabited by Archibald MacLeish; Arthur Schlesinger, Jr.; William Meredith; and Louis Untermeyer. Within a few years the life of the Udalls—and the culture of Washington, D.C., as well—would be transformed. None of that happened immediately, however.

In February 1959, at a congressional joint session observing the 150th anniversary of Lincoln's birth, Carl Sandburg—poet, folksinger, Lincoln biographer—depicted the president's life with the dramatic vocal repertoire so typical of the platform veteran, ranging in tempo and volume from a high, piercing near-shout to a low, deliberate, intimate murmur that brought to mind his fog that comes on little cat feet. As he often did for emphasis, he slowly repeated a telling phrase or sentence. Spellbound, the congressman from Arizona described the speech in the *Congressional Record* as "surely one of the noble moments of this, or any other Congress." In Stewart's lexicon, "noble" is a word of high praise.[3]

Our nation's post of poet laureate did not yet exist; the nearest comparable position was poetry consultant to the Library of Congress, usually a one-year appointment. Sandburg had declined the honor several years earlier, but Robert Frost joyfully accepted for 1958–59. The duties could be minimal, only requiring the poet's presence in Washington during four separated weeks in the fall and spring. In the words of Frost's admiring friend and fellow poet, Louis Untermeyer, himself selected as the consultant in 1961, the honoree was to serve as "a poetic radiator, radiating a love of poetry over as many miles as possible."

Frost had bigger ambitions. He did the usual, making himself available for consultation concerning the library's poetry collection, greeting visiting literary lights, encouraging fellow poets to record their works for the library, and presenting two invitation-only talks. For Frost that was far from enough. Now that he occupied what author William McGuire called "poetry's catbird seat," he intended to use it as a fulcrum of power. "He wanted to be consulted about everything," according to biographer Jeffrey Meyers. Apparently with encouragement from a White House friend—former New Hampshire governor Sherman Adams, President Eisenhower's chief of staff—Frost

began advocating the appointment of "someone in the cabinet for the arts." Not everyone was paying attention. Frost, often touchy, sensitive to slight, was determined not to be ignored. At a press conference, the unhappy poet complained that he had been "consulted only three times by the White House, only once by the Supreme Court [Justice Felix Frankfurter], and not at all by Congress. I think something ought to be done about it."[4]

Frost's gripe reached the breakfast table at Crest Lane. "We both loved his verses," and the Udalls agreed that "something ought to be done." Udall remarked years later that "[in 1959] I was a lowly three-term Representative," a little-known "congressman from nowhere," but he boldly wrote to Frost, not in Washington at the time, inviting him "to consult" when he returned in May for his final session at the library. Frost accepted the invitation to dinner on May 19, 1959. "We were overwhelmed when he accepted."[5]

In the mores of capital life such a party—even a small one—called for a catered dinner with servers and kitchen help. The Udalls were schooled enough in Washington folkways by now to know this, but they could not afford such luxuries. Lee was not bothered; she went ahead with dinner plans. Although far along in her sixth pregnancy, she readied the house and prepared dinner. She mustered a corps of homegrown waiters and kitchen aides: Tom, eleven; Scott, ten; and Lynn, nine. (How Lori, seven, and Denis, three, assisted is unrecorded.) The other guests were authors Senator and Mrs. Dick Neuberger of Oregon; Representative John Brademas of Indiana, later to be New York University president and head of the President's Committee on the Arts and Humanities; Representative Frank Coffin of Maine, a future federal judge and author; Gilbert Harrison of *The New Republic*; and Kay Morrison, called by a Frost biographer the poet's "manager, mistress and muse." Years later, Coffin sent Udall, "for your archives," an account of the evening, based on notes he said he wrote the following day. There are differences between his account and Udall's recollections. Coffin dated the party on May 20; he did not include the Neubergers but did include Nancy [Mrs. Gilbert] Harrison and Representative Edith Green of Oregon. Undoubtedly all those named attended one or more of the Udall literary dinners and "consultations."[6]

The rear porch overlooking the woods and the river was the scene for much of the Frost evening. The gathering was a success, three hours filled with good food and talk of poetry and politics. It was so enjoyable that many more such "consultations" with Frost and other writers and thinkers would follow.

Stewart recalled years later that the parties led to "a lifetime opening of vistas." Above all, for Stewart's and Lee's future cultural activities it was the contact with Frost that was the key, and Stewart once declared that "Frost's friendship meant more . . . than anything [else] that has come into our lives."

None of the subsequent evenings at the Udall home, however, had a comparable immediate aftermath. As Stewart tells it, "Lee would not go to bed with a dirty kitchen. She and the older children got to work, but I had an early appointment the next day and went to bed. I didn't know when Lee came to bed. Around three the next morning she felt the signs, got up, and drove herself to the hospital. When I awoke that morning I found a note saying she had gone to the hospital." Baby James—now known as Jay—made his arrival; he is the author of three books of poetry, perhaps a subliminal legacy of the event on the eve of his birth.[7]

Congressman Udall described the Frost dinner in a bylined newspaper report to his Arizona constituents. He wrote, "Frost looks and talks like the New England farmer that he is . . . and his conversation has the same tone and quick insight as his poetry." Frost "described 'vividly' for us his experiences as a 10-year-old campaigner for Grover Cleveland in the 1884 election. He recalled the torchlight songs and chants of that campaign." The congressman became somewhat professorial in his report: "[A] poet, according to Frost, has license to use a part as a symbol of the whole (this is the poetic device of synecdoche) but he believes that non-poets often go astray in attempting to form universal truths out of assorted half-truths"—mentioning Marx, Lenin, and American tax reformer Henry George.

As the evening progressed, Udall reported, Frost challenged his congressional listeners: "I would hate to see you abolish poverty and distress—they have done so much for the arts!" Struggle is vital, he declared: "If I had one gift to give to mankind, it would be character." Politicians who use ghostwriters also drew Frost's disdain, "If one lacks capacity to do something . . . he should not pretend that he can do it." Udall concluded that "Robert Frost is surely one of the greatest living Americans. After sitting at his feet one understands why poems outlive laws."[8]

Stewart thus revealed to home-state voters that he was not the stereotypical politico, that there was more to him. He remained a successful campaigner, winning a fourth term in 1960 and making an impact in national politics as well.

Chapter 3

Frost Steals the Show

UDALL WAS STILL A RELATIVE NEWCOMER in Congress, but his political aggressiveness was drawing notice. "His political instincts are sharp," a *Wall Street Journal* reporter wrote. "He is a liberal and on occasion has been a fighting one, quite willing to challenge his seniors in Congress in order to win his way.... [But,] he is willing to compromise." Stewart served on both the Interior Committee and the Education and Labor Committee in the House; it was his work on the latter that led to association with John F. Kennedy, a connection that would lead to greater opportunities. Udall had been an ardent supporter of Adlai Stevenson, the Democratic presidential nominee in 1952 and 1956, and a potential seeker of the nomination again in 1960. But, Udall recalled for *New York Post* writer William V. Shannon in December 1960: "I can tell you exactly when I became a Kennedy man. At 3 A.M. the night Congress adjourned in September, 1959, I stopped by [Sen. Kennedy's] office and told him I wanted him to be President.... I became a convert through working with him on the labor reform bill. We were both members of the conference committee that sweated over the bill that became the Landrum-Griffin Law. I liked the way his mind worked, the way he attacked a problem and stuck with it."[1]

In a day when presidential primaries were not widespread—and Arizona did not have one—a surprising maneuver in the Democratic Party caucus that selected the state delegation for the 1960 national nominating convention became a major factor for change in the Udalls' lives, and in Frost's life as well.

Led by Stewart, a cadre of "liberals" (in Arizona terms) surprised the state's pro–Lyndon Johnson Democrats and captured Arizona's

1960 convention delegation for Senator Kennedy. It was a remarkable coup, and it propelled Udall into the national political scene.

Months earlier, Frost showed that Kennedy was his choice, too. He prophesied, "The next president of the United States will be from Boston. . . . He's a Puritan named Kennedy. The only Puritans left these days are Roman Catholics." Kennedy, possibly a bit bemused by the statement, wrote Frost: "I don't know how you said that, but thanks just the same." Kennedy and Frost had an affinity, and often during his presidential campaign, Kennedy would quote from Frost's "Stopping by Woods on a Snowy Evening" to conclude his speeches: "I have promises to keep, and miles to go before I sleep."[2]

There had been hints that Kennedy might choose Udall for a post in the cabinet. A westerner was needed and, also, according to the *New York Post,*

> Udall's religious affiliation was one of the factors that was probably considered in his [Udall's] selection. Sen. Kennedy was clobbered in the mountain and desert states largely because the officials of the Mormon Church openly indorsed [*sic*] and worked for Nixon. Looking ahead to 1964, the President-elect can see that his Mormon fence is one that badly needs mending, and a Mormon Secretary of the Interior could help greatly.[3]

A few days after the 1960 election, Frost and fellow poet William Meredith—heading east after "barding around" in California—paused in Tucson to visit the Udalls, who were there for the election. Frost dedicated the university's new Poetry Center, and he and Udall generated publicity. Frost craved assurance, adulation, and public attention, and one Frost biographer believes that Udall, "ambitious and anxious to be accepted," was seeking "to enhance his reputation among the eastern elite" by associating with the poet. Frost told a friend, "Udall is moved by the fact that he knows a man who writes poetry." Frost could be small and peevish at times. Whatever the tone of his remark, it probably had truth in it; but there was, as well, validity in Udall's interest in poetry.[4]

Frost and the Udalls rejoiced over the election results, anticipating that with the new president the administration would pay more attention to the arts. On November 25, after Frost's departure, Stewart generated the idea that would create a memorable beginning for Kennedy's presidency. Something was brewing in Washington; Kennedy asked Stewart to return

to the capital and meet with him early in December. To Kay Morrison, Stewart wrote:

> I'm plotting against Robert, and want the benefit of your judgment.
>
> I'm to see Senator Kennedy next week, and plan to urge that he invite Frost to be a White House guest inauguration week, and take part in the inauguration ceremony. (Robert, as I conceive it, would, after the inauguration address, deliver a poet's benediction of some kind. . . .)
>
> Now, I want to know (via return airmail) whether for any reason you would consider it inadvisable for the Senator to make the overture—assuming I can persuade him to do so. I've tried the idea out on several discriminating friends here, and they think it would be a masterstroke for both poet and president.
>
> Do write, and give me your advice.

Kay Morrison replied, "What a great idea! It would mark the beginning of the age of 'Recognition of Excellence'. . . . I have thought carefully. . . . No prose—his is loose and unplanned—great in its own way—but not suitable for such occasion. What could be better as a closing after we all sit stunned than to have Frost say 'The Gift Outright'—no words before, no words after. It is top Frost and a great American poem. He never can do better." She continued, "As you know he doesn't write for occasions. Any attempt always ends up with the clock a quarter before the appointed hour and R. F. with a bad case of shingles."[5]

On December 1 at Kennedy's Georgetown home, the president-elect offered Udall the post of Secretary of the Interior, and Udall accepted. As Udall rose to leave, he suggested, "You might consider having our mutual friend Robert Frost take part in the inauguration ceremonies." "Doing what?" Kennedy asked. "Why, reading a poem at the beginning, or in the middle, or at the end." "Oh no!" Kennedy responded. "You know that Robert Frost always steals any show he is a part of." Nonetheless, he asked Udall to determine if Frost would be interested, and report back. Immediately after that conversation, author-journalist Irving Brant met Udall when he returned to his congressional office. Udall told Brant that when he broached the idea of Frost's participation, "Kennedy was silent for a time, then answered 'You remember, there was a second speaker at Gettysburg.'"[6]

23

Udall met Kennedy again on December 7 and handed him Kay Morrison's letter and a copy of "The Gift Outright." Kennedy read the verse and suggested it needed a somewhat different ending, proposing a change of "such as she would become" in the last line to a more emphatic "will become," and then musing, "but who am I to tell him how to use his words?" He then sent Frost an invitation to participate in the ceremonies: "I know that it would give the American public as much pleasure as it would my family and me."

The poet responded:

> If you can bear at your age the honor of being made president of the United States, I ought to be able at my age to bear the honor of taking some part in your inauguration. I may not be equal to it but I can accept it for my cause, the arts, poetry, now for the first time taken into the affairs of statesmen. I am glad the invitation pleases your family. It will please my family to the fourth generation and my family of friends and, were they living, it would please inordinately my kind of Grover Cleveland Democratic parents.[7]

A few days later, Kennedy expanded on Udall's inspiration. When Washington socialite Kay Halle of the inaugural committee proposed that invitations to the ceremonies be extended to cultural leaders, Kennedy seized the idea. Invitations, sent over the signatures of the President-elect *and* Mrs. Kennedy, were telegraphed to 186 persons prominent in the arts, sciences, and humanities. Many of the invitees attended and, as Miss Halle noted, "It is the first time—as most of the eminent group commented—that the creative Americans had been considered the equal of the politicians." Thanks to Udall's initiative, President Kennedy, with Frost by his side and a host of the nation's cultural elite in attendance, signaled that the arts would be emphasized in his new administration. There was promise in the air; America's Camelot era was beginning.[8]

Frost decided to write a poem for the inauguration—a move Mrs. Morrison would have sought to prevent had she known about it. When the Udalls met his train at the Washington Union Station on January 18, he had "a twinkle in his eyes," Udall remembers, "and demanded an Interior Department job, 'as Under Secretary of Trees.'" He revealed to a surprised Stewart that he was preparing a poem for the ceremony.

The poet was in high spirits, relishing every moment. That evening he was a guest at a dinner party at the Georgetown residence of Florence Mahoney,

a Democrat of means, known for her intimate dinners in a small home filled with antiques and fine art. Frost, elegant in a new Italian suit, joined Lee and Stewart in their car ("I was still a Congressman; I didn't have a limousine," Stewart recalls) to drive to Mrs. Mahoney's home on Prospect Avenue overlooking the Potomac. In addition to Frost and the two Udalls, there were only four other guests, but *such* guests: former president Truman, Mrs. Truman, the Trumans' daughter Mrs. Clifton Daniel, and Adlai Stevenson, twice the Democratic nominee for president and soon to be ambassador to the United Nations. Stewart remembers Frost's exuberant declaration as he and the Udalls arrived at the house, "Here we are among the Mighty!"

There was more to come. President-elect Kennedy stopped by for coffee, and they all joined in a discussion of the world troubles that the new administration would face. It was heady stuff. Frost was ecstatic and, Stewart conceded recently, "So were we."[9]

Frost was housed that night and the next in a guest cottage facing Canal Road just below Florence Mahoney's home. Also there, in the temporary absence of Kay Morrison, was Stewart's sister Elma, who was in Washington for inauguration week. Before the party, Elma helped the poet adjust his new suit, of which she recalls he was quite pleased. Lee had instructed her on how Frost would like his breakfast, particularly noting how much milk he would want in his coffee. While a major snowstorm engulfed the capital the next day, January 19, Elma observed that Frost remained in his room working on his new poem. By the morning of the twentieth he had completed forty-two lines, more or less.

In a chauffeured limousine, Stewart and Lee drove to Frost's quarters to escort him (and Elma) to the Capitol. The poet greeted them with startling news: "I've decided I want to say a few things besides reading my poem. Will that be all right?" Udall, taken aback and concerned that Frost would upstage Kennedy, asked how long it would take. More uneasy by the moment, the secretary-designate listened at the door to Frost's room as the poet read aloud his "Dedication." It was not long, and a somewhat relieved Udall saw no problem in having him read it as a preface to "The Gift Outright." As they drove to Capitol Hill through the gathering throng, however, another problem arose. Frost fretted that the poem, typed on a borrowed typewriter with a worn ribbon, was hard to read. In the sunlight he might have even more difficulty.[10]

They went to Udall's office on the first floor of the Old House Office Building (now the Cannon Office Building). Stewart knew of a "speech typewriter" with larger-than-usual type, and he asked Elma to retype the newest draft. She made two carbon copies ("one for myself") and recalls that the typewriter ribbon was blue, commonplace on the Hill. There was no time to memorize the verse. While Elma joined Lee's and Stewart's mothers in reserved seats for the inaugural, Frost, Stewart, and Lee proceeded to the Capitol to join the official party as the dignitaries moved onto the East Front platform. The day was stainless-steel bright, rocked with a wind straight from the Great Plains, and miserably cold. I, a new arrival from the southern California coast, stood in the crowd below—shivering despite new long johns and layers of clothing.[11]

As much of the world watched on television—including Polly and her class of fifth-graders in Ventura—Frost's moment came. "My heart sank," Udall recalls, as the old man "struggled to read the fresh-minted stanzas from the fluttering paper. But then, Robert Frost squared his shoulders, abandoned the dedication verse, and with moving simplicity spoke the familiar lines of 'The Gift Outright.' His faltering had added a special note of human warmth to the occasion. . . . A more self-conscious man would have sat down dejected, but I noted a look of contentment on his face." The *Washington Post* reported, "Robert Frost in his natural way stole the hearts of the Inaugural crowd yesterday with a poem he recited and another which he couldn't read because the sun's glare hid the words." The authors of one Frost biography observed, "In a way, Senator Kennedy's joking prediction to Stewart Udall had come to pass."[12]

Following the official luncheon in the Capitol, Frost and the Udalls rode in the parade down Pennsylvania Avenue past thousands of chilled spectators to the White House viewing stand—surely a memorable day for the trio: the old man from Ripton, Vermont, and the youngish couple from Mesa and St. Johns, Arizona. That night, Frost was up until 2:00 A.M., having the time of his life at an inaugural ball. "If a man his age [he was 86] could be said to gambol," Stewart observed, "Robert gamboled through the rest of the week's activities." Noting that Udall had become the poet's "friend and confidant in official Washington," a perceptive writer for the *Post* wrote that the politician was leading the poet "gently and perhaps a bit gingerly through the corridors of power." Those were excellent word choices—gently and gingerly.[13]

Chapter 4 ———————————————————————

"Secretary of Things in General"

FRANKLIN D. ROOSEVELT'S Secretary of the Interior, Harold Ickes, created an elegant sixth-floor suite for himself and his successors when the Interior Department Building rose in the 1930s. For incoming Secretary Udall it presented a dramatic change. He moved from two cramped rooms for himself and staff in the Old House Office Building to a lofty office nearly two stories high with a vaulted ceiling, wood paneling, a fireplace, and windows on three sides offering views south to the Mall and west and north. Stories, probably apocryphal, told that Ickes ordered the room to be at least one inch larger than that of any other cabinet officer. Udall once called it "my basketball court."

It was said that, after Ickes, some Secretaries used the big room for ceremonies only, choosing instead to work elsewhere in the suite. Not Stewart. He placed his desk at the south end and hung above it a large color photo of Rainbow Bridge, the great sandstone arch in southern Utah. Additional oversize photos of southwestern scenery and prize pieces of Indian art were placed about the room.

Three assistants had desks in an adjacent wood-paneled office: Udall's right-hand man from his House office, Orren Beaty, Jr., a former New Mexico and Arizona newsman who became the assistant to the Secretary; a young District of Columbia attorney, Walter "Bill" Pozen, whose assignments chiefly involved District of Columbia matters; and I. Beyond the far end of our office a door led to a short hall that opened to a large back parlor that would figure in Udall's future writing projects. Just outside our office a private elevator descended to a fifth-floor private dining room and a conference room, and to the secretarial limousine garage in the basement.[1]

The statutory responsibilities of the Secretary of the Interior covered national parks, coal mine safety, public lands grazing, mineral research, commercial fisheries, wildlife refuges and fish hatcheries, mapping the nation, administration of islands in the far Pacific, electric power generation and distribution, water resource research and development, oversight of American Indian reservations, allocation of oil import permits, and operations of the Alaska Railroad. Each touched an interest group somewhere—invitations to controversy, targets for writers from the smallest of publications to major dailies and networks. Udall faced still more scrutiny, for he also was closely observed by local reporters because of National Park Service management of the Mall, Rock Creek Park, George Washington Parkway, and scores of circular, rectangular, and triangular parks big and tiny throughout the District of Columbia. Soon after Udall settled into Interior's hot seat, a *Saturday Evening Post* writer called him "The Secretary of Things in General."[2]

It was a fitting phrase, but that *Post* writer, Robert Manning, missed some of the "things" that interested Stewart. Manning gave little notice to Udall's cultural interests, noting only that Frost had been a Udall dinner guest, and that Stewart displayed in his office a photo of eldest son Tom with the poet. Had Manning written a few weeks later, he would have discovered that "Things in General" included activities not in the *Government Organization Manual.* Stewart added promotion of the arts to his workload.

When I joined Secretary Udall's staff in February 1961 I learned that he believed that "Frost's trip to the inauguration had more than passing significance. . . . [Now] poet and president had joined together to affirm the hope for a new American age of excellence." The reception given Frost's inauguration poetry inspired Udall to ask First Lady Jacqueline Kennedy to lend her support for an evening event featuring the poet; the answer was "yes." With that, "It was no problem to get the rest of the cabinet to join in [the sponsorship]."[3]

But, where to present such a program? Author Brendan Gill expressed it succinctly, "Accommodations for the arts were scant indeed" in Washington. Just across Eighteenth Street from the Interior Department building was Constitution Hall of the D.A.R. (Daughters of the American Revolution), but it was too large and expensive. The few other nonfederal halls were also

unsuitable for various reasons. Interior's auditorium was too small, as was Commerce's. The State Department's new west auditorium seemed the best available site. Used for Kennedy's press conferences, it could seat 760 guests, which Stewart considered "about the right size." It was more conference hall than theater, with no dressing rooms, no footlights. The carpeted stage was about six inches above the floor level of the first row. Acoustics were questionable, but it became the venue for all but one of what Udall called the President's Cabinet Artist Series, a name echoing that of the University of Arizona Artist Series of Stewart's, Lee's, and our college days. The State Department cooperated, but it was Udall's show. Concerning the selection of artists to be invited to participate, Stewart declares, "Lee and I made all the decisions."[4]

For "An Evening with Robert Frost" on May 1, 1961, logistical arrangements were handled by Udall's staff; engraved invitations addressed in the Interior Secretary's office went to guests invited by each member of the cabinet. A National Park Service photographer, Abbie Rowe (who also took White House photos at times), covered the event, and Park Police provided traffic control at the Twenty-third Street entrance. Udall's receptionist, Maxine Lowry, recruited young Interior Department women to serve as ushers. My role was to oversee the operation.

Stewart contacted Frost's publishers—Holt, Rinehart and Winston—and the firm's president, Alfred C. Edwards, delivered a handsome limited-edition hardbound book as the evening's keepsake; it bore the presidential seal on the cover and featured a presidential eagle woodcut in bronze ink on the title page. Its pages included Frost's special "Dedication" written for the Kennedy inaugural but only delivered in part; his "The Gift Outright," which the poet recited when he could not read "Dedication"; and Kennedy's inaugural address.[5]

Although Mrs. Kennedy was the honorary sponsor, neither she nor the president attended the Frost program or any of the subsequent "evenings." In reporting the Frost performance, the press attributed the absence of the president and Secretary of State Dean Rusk to "the Lao [sic] crisis." It was an omen. Recently I asked Stewart about Mrs. Kennedy's absence from the Frost program and all the succeeding programs at the State Department hall. He accounts for her failure to appear by mentioning her fragile health and motherhood responsibilities, noting that she had suffered two miscarriages and had two small children to care for.[6]

Frost, of course, was ready to perform at the drop of a hat, and thereon hangs a slight hat story. The Udalls and Secretary of the Treasury Douglas Dillon (the ranking cabinet member present) served as hosts for the black-tie affair, greeting guests as they entered the lobby. When Frost arrived, Stewart asked me to escort the poet to the stage entrance. Our passage led down a well-illuminated side hall to a stage door where I became the only witness to a bit of the poet's subtle humor. Frost was wearing a tuxedo that in the strong light appeared to be green with mold, and he carried a grey fedora. He needed a place to leave the hat, but none was immediately evident. Lining the hall were enclosed telephone booths reserved for the media covering Kennedy press conferences, each marked with a name: *New York Times*, Associated Press, Tass, Reuters, *Washington Post*, and so forth. Frost read the names aloud as he passed, then abruptly turned and walked back to the booth of Tass, the Soviet press agency. Placing his hat on the seat inside, he brightly remarked to me, "It ought to be safe here."[7]

A lectern and three straight chairs occupied center stage. Udall opened: "In these turbulent times, amid the rush of events, it is good to hear of things as old as the hills." Then Dillon introduced Frost. In reporting the event, *Christian Science Monitor* correspondent William Stringer wrote that the poet "charmed the evening with quips and short readings and deep comments," and quoted portions of Frost's remarks:

> Poetry takes science with a certain amount of antagonism. . . . Keats said science spoiled the rainbow. And someone had me on the phone from England to talk against spoiling the moon for lovers. I felt a little bit of that myself, with sputniks spoiling my sky. . . . Science is man's greatest tool. But man is the owner. He considers what it becomes him to do. He finds that out, you know, from the book of the worthies. That is, the humanities—good plays, stories, essays, philosophy. . . .
>
> In the middle of politics and the world's din you like to have something to stay your mind on.

He closed by telling how, long ago, he halted his horse and watched the woods fill up with snow: "And I have miles to go before I sleep."[8]

In the next morning's *New York Times*, under a headline, "Udall, the Demos's

Art Lover, Is 'Hatchet Man' to Republicans," David Halberstam reported that Udall

> appears to be creating two contradictory reputations. The first is as the fiercely partisan member of the new cabinet, who is not above baiting Republican Congressmen with reminders of the difficulties that might develop over water-resource projects dear to their hearts.... The second reputation is as a member of the cabinet with a deep concern for the relation of art to government, and a determination that the Government should encourage its writers and artists.... [He was] the initiator and driving force behind the Frost evening.

While the Secretary was "the object of bitter criticism by Republicans," Halberstam wrote, Udall "had appointments with Aaron Copland, the composer, [and] Arnold J. Toynbee, the historian, and lunch with writer and scientist Sir Charles Snow."9

Afterward, Attorney General Robert Kennedy penned a short note to Udall, "Stew: Let us know if he [Frost] comes down again, as he has stolen all the Kennedy girls."10

To Udall, Secretary Dillon's interest in Frost seemed reserved, but Stewart knew that the treasury secretary had a great interest in Chinese art: "He was from a different world, a fortunate family, New York investment banker, former ambassador to France." True, Stewart's world *had* been different, but he and Lee were changing rapidly. Observers began ranking the Udalls among Washington's cultural movers. Under a headline in large type, "Udall Leading Capital's Culture Kick," columnist Betty Beale declared: "This town has gone absolutely mad about culture ... with big boosts from Jacqueline Kennedy, it has become chic. ... Oddly enough, much of the new cultural trend seems to swirl about a man whom you would not describe as the chic type at all—Secretary of the Interior Stewart Udall, a rugged, outdoor fellow with a crew cut and a brusque manner—he looks like a football player." Similarly, another journalist reported, "Culture has been on the march in Washington since the Kennedy administration came to power. ... [Udall has] sparked the administration's unprecedented drive to emphasize the climate for culture that has swept the nation's capital."

Initially, political gurus had pigeonholed Udall as a tough-minded infighter for the administration, bluff, plain-spoken, a man "with a lust for politics and a habit of landing right in the middle of the fight." That was a fair characterization, but not the whole story. Douglas Cater, writing in *Horizon*, gave credit to Udall as "really the official representative of the Kennedy Administration in dealing with the cultural arts and sciences" through a series of gestures to the arts community. As another writer discovered, Udall's often abrupt manner "sometimes overshadows his words which reveal sensitivity and a deep concern that America shall shine for the things of the spirit as well as for its material achievements."[11]

It became no surprise to see in the corridor leading to the Secretary's office a California governor with his water engineers or a band of Montana Indians with their Washington attorney, but with Stewart Udall in the secretarial suite you never knew when you might run into a Pulitzer Prize–winning author or a world-class musician.

"A Golden Age of Poetry and Power"

As a cabinet officer saddled with many points of potential policy dispute, and as a partisan politician with an occasional tendency to put his foot in his mouth, Udall's every move drew attention from news hawks. One incident about tickets for a Democratic dinner, scarcely noticeable had he remained a congressman, created a traumatic day or two in the paneled offices; there were rumors that Udall might lose his job. Frost popped into the office at the time, and Stewart asked him to sit in on a press conference called to deal with the tempest. Frost remained silent throughout, but the presence of America's grand old man of poetry offered quiet evidence of a belief in Udall's basic good character.[1]

Stewart believed that "if we could change people's sense of values we would build a bridge between art and government.... The artists have the wisdom and the insight we need so badly." Moving quickly, probably too quickly, he solicited comments from several literary and musical celebrities concerning a proposed article to advocate a federal government subsidy for the arts. He received mixed responses:

- Praise from Leonard Bernstein: "Many of us have waited a long time for some expression of interest to appear in Washington." He listed three considerations, the last of which proposed that funds be allocated "on a state basis," not "a direct Federal subsidy."
- A surly reaction from John O'Hara: "I would first have to know the name of that magazine. I would then have to have your assurance that what I said would appear exactly as I wrote it." He presumed that Udall would be paid for the article, and might

give the payment to a charity, but "there are many charities of which I do not approve."

- ✦ Interest from Enrico Donati: "It is high time that the visual arts are recognized as actively by the government as the performing arts already have been." He offered five recommendations for federal action.
- ✦ Caution from Jack Levine: "I must in candor confess uneasiness rather than enthusiasm." He cited past experiences with federal censorship of art and concluded, "Because of these and other experiences I tend to regard Federal patronage with a jaundiced eye."[2]

Perhaps because it was ahead of its time, Udall's proposal faded away. For a while.

A few weeks after the Frost "Evening," Udall invited Carl Sandburg to appear—a logical, predictable next move. Stewart told a reporter, "What I am trying to do is to break down this picture of the poet as something far removed from ordinary life." Sandburg chose October 26, 1961, for his appearance, replying, "My friend, Vachel Lindsay, used to call his program 'Higher Vaudeville.' I would not object to that term for the recital I will give." Sandburg's publisher, Harcourt, Brace and World, provided the guests a colorful memento containing the text of his Lincoln talk before the Congress in 1959.

For the "Evening with Carl Sandburg," in contrast to the Frost program, State provided a "dressing room" of sorts—a small room furnished with a table and mirror, a pitcher of water, bowl, and a water glass. It had been reported earlier that Frost carped that Sandburg spent time getting his silky white locks combed "just so" over his forehead before performing; I saw that the story was correct. While Sandburg prepared to go on stage, I remarked that, like him, I was born in Galesburg, Illinois. He signed my copy of the keepsake, "Boyd Finch with salutations to you & the Cottage Hospital Gb. Carl Sandburg." He told me of a baseball game that a Galesburg team once played against a team from my family's hometown, Aledo, forty miles distant; they met at a midway point, a field at Alpha, Illinois. At least half a century had passed, but Sandburg recalled "a dandy shortstop" for Aledo who wore "a plug hat" during the game.[3]

Two of the president's sisters, Jean Kennedy Smith and Eunice Kennedy Shriver, were among Sandburg's overflow audience. Also among those present was a congressman of the distant future: the Udalls brought their thirteen-year-old son Tommy. The cabinet displayed greater interest, and the guest

list grew also because invitations went to every member of Congress. Stewart persuaded secretaries Rusk of State and Hodges of Commerce to provide opening remarks. Sandburg rambled through "literary criticism, poetry readings, and random irreverences towards a former president [Eisenhower], a most ungrammatical president," *Washington Post* writer Dorothy McCardle reported. She wrote that Sandburg warmed Democratic hearts with praise for Rusk's handling of his international burden. After about an hour of what he called "trifles and offerings," Sandburg took up his guitar and sang ballads.

For the *Washington Evening Star*, Mary McGrory wrote,

> Sure of his audience as an old shakespearean, the white-haired, craggy-faced minstrel closed with a spiritual that was calculated to pluck at the heartstrings of the eminence before him:
> "I'm your child, Lord Jesus, I'm your child.
> Every hour, give me the power to go through."

Ms. McGrory reported that his engagement "may have made him a rival in the affections of the White House of another poet, 87-year-old Robert Frost, who has had it all his own way up to now."[4]

Udall's personal contacts continued with Sandburg and his family. One of Sandburg's daughters, Helga, wrote to him, "I can't tell you how delighted I am with your interest. I look upon you as the benefactor of the poets and my father's natural shield-bearer."[5]

Udall next contemplated inviting Spanish cellist Pablo Casals to present an Artist Series program, but Stewart was upstaged. Udall told an interviewer later, "I was going to have Pablo Casals over. . . . Kennedy's people learned of this and decided to have him at the White House." For Casals's highly publicized concert, Stewart was unable to go, but Lee attended, escorted by artist/educator James "Jim" McGrath of Santa Fe—of whom more later.[6]

Stewart considered the two "Artist Series Evenings" a success and believed that artists from other fields would be equally well received. In a letter to fellow cabinet members he called himself "your self-appointed chairman of arrangements" and asked his colleagues to rate their preferences as to five possible honorees, all suggested by Lee and himself. In the Udall Collection at the University of Arizona are replies from five of the cabinet. The results of the poll were not especially helpful. Marian Anderson was the first or second choice of four of the cabinet, the fifth member favored only two art-

ists, Leonard Bernstein and William Faulkner. Secretary of Defense Robert McNamara listed four possibilities as "excellent" and voted "no" on Faulkner. Artur Rubinstein was the first or second choice of two members. With that mixed result, Stewart and Lee simply proceeded on their own, and three of the artists—Leonard Bernstein, Thornton Wilder, and Marian Anderson—subsequently appeared in the Artist Series. Rubinstein and Faulkner never made it.[7]

A *Washington Post* headline on March 12, 1962, evidently annoyed Udall: "Goldberg Becoming Unofficial Secretary of the Arts." The basis for the story was the success that Secretary of Labor Arthur J. Goldberg had in settling a labor dispute that threatened to cancel the Metropolitan Opera season. "We had an outpouring of mail," Goldberg told the press, and "[that] overwhelmingly favored Federal encouragement of the arts." A clipping is in the Udall Collection; on the margin is written "Modest fellow."[8]

Frost's eighty-eighth birthday inspired a large, glittering party, one that reflected the rise of the Udalls in Washington's cultural scene. Al Edwards, Frost's publisher, brought the idea to Stewart, who carried it to a spectacular success.

In 1960, Frost had testified before a Senate subcommittee in favor of a bill to establish a National Academy of Culture; that bill went nowhere, but Congress awarded a gold medal to Frost later that year. An occasion to present the medal, however, did not arise until the poet's birthday on March 26, 1962. That day began with a White House "consultation." Frost and President Kennedy talked at length and Frost received the congressional medal. That evening, Udall presided as master of ceremonies at a banquet underwritten by Holt, Rinehart, and Winston at the elegant Hall of the Americas in the Pan American Union Building. A grand mixture of more than two hundred prominent governmental and literary persons attended. Fifteen principal guests lined the dais; a photo shows Stewart and Frost at the center of the table and Lee seated between Chief Justice Earl Warren and Ambassador Adlai Stevenson.

Poetry and power shared the evening, which featured a parade of speakers in praise of Frost. The power included Chief Justice Warren, Justice Felix Frankfurter, and Ambassador Stevenson ("Frost is the poet of all time and all America"). Among the poets were Robert Penn Warren ("It is, you might say, a motley group, who else but Robert Frost could bring them together?") and

Mark Van Doren. Stewart remembers Van Doren's talk as being particularly moving; the poet praised Frost for "dozens, hundreds" of lines to remember ("No living poet matches him here"). Van Doren recited twenty-eight of the memorable lines, seven of which were underlined on a copy of Van Doren's text that he gave to Stewart:

+ I sha'n't be gone long.—You come too.
+ Something there is that doesn't love a wall.
+ Two roads diverged in a yellow wood.
+ One could do worse than be a swinger of birches.
+ And miles to go before I sleep.
+ The land was ours before we were the land's.
+ I had a lover's quarrel with the world.[9]

In introducing Frost, Udall expressed gratitude to "this strange and proud and humble man" and "pride that a poet would feel at home in this town—and in this company." Udall added, "He has taught us of the need of being versed in country things, and with his earth-wisdom he has quickened our feeling for brooks and woods and snow and stars and living creatures. He is the only poet I know who can take you on a nature walk indoors." And, as he viewed the assemblage, Udall recalled Frost's inauguration day hope that America would enter "a new Augustan age . . . a golden age of poetry and power." It was easy that night to believe that the glorious age was beginning.[10]

When Frost moved to the lectern it was six minutes after midnight. Holding forth for twenty-five minutes, the old man had a grand time. Poet Louise Bogan, in an acerbic mood, said he "rather maundered on," but when he began to recite his own poems it was "fine." He reveled in the attention, remaining until 1:00 A.M. shaking hands. Frost called the night "the height of my life." In the *Washington Post*, Jean White observed, "It symbolically marked the height of recognition of the importance of arts in the American way of life, a special point of emphasis in the Kennedy administration." *Life* magazine placed Frost's face on the front of its next issue and devoted ten pages to Frost and his poetry, interspersed with appropriate photos. The editors called him "America's Ageless Poet," and declared, "Of all American poets the one who has done more to destroy this distrust of poetry is Robert Frost."[11]

"Something has happened in Washington," a newspaper columnist observed. "Until a year ago the city was practically a cultural desert. Now it is becoming

a promised land for the writer, the poet, the artist and the musician." Then came the Kennedys' grand dinner for the French minister of culture André Malraux, during the time the *Mona Lisa* from the Louvre was exhibited at the National Gallery. The guests (including the Udalls) were 165 gifted persons whose "presence at a White House function would have been most unusual, if not improbable, before the Kennedy regime."[12]

The cabinet's Artist Series continued with Attorney General Kennedy introducing contralto Marian Anderson on March 22, 1962. In proposing the evening, Udall remembered that in 1939 the D.A.R. had not made its hall available to her. She remembered, too. When Stewart called to invite her for an "Evening," she replied that after the D.A.R. rejection the Interior Department [under Ickes] had "gone out of its way for me," enabling her to sing for a massive crowd in front of the Lincoln Memorial. "Sure, I'll come," she told Udall. The evening offered her opportunity to present a great many Negro spirituals; the sixty-year-old singer closed her evening with several lieder, including Schubert's *Schwanengesang*. It wasn't truly Miss Anderson's "swan song" however; she retired three years later.[13]

At an April 1962 Artist Series evening, Secretary of Health, Education, and Welfare Abraham Ribicoff introduced Thornton Wilder. Today Udall recalls that when he telephoned Wilder to invite him to present a program, Wilder responded, "Of course I'll come. You people have put a lighthouse on the hill." At the auditorium, Wilder did not seek a phone booth for his hat as Frost had. Instead, a reporter wrote, "Wilder faced the black-tie audience in a crumpled suit and wearing his battered hat [was he, for the moment, the stage manager in *Our Town*?] but for more than an hour he held everyone spellbound as he read from his works. . . . [It was] something to watch and ponder—political Washington captivated by an intellectual." After a visit with Udall later, Wilder wrote, "Stew—Lots of good wishes from your guest and lots of thanks. Thornton W. 'Cactus Joe.'"[14]

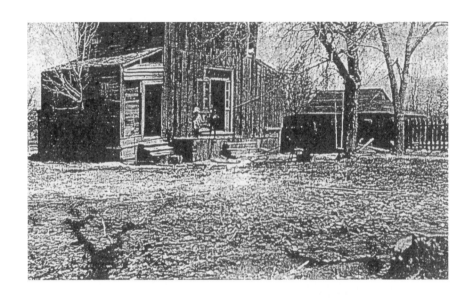

Stewart Lee Udall was born January 31, 1920, in this 1885 structure in St. Johns, Arizona. His mother called the drafty house her "air castle." The original photo is lost; this poor copy is from a Udall family album.

▲ *The Udall family's bungalow in St. Johns was home to Stewart from 1922
into his college years. This view shows the house as it was in the 1940s.*
From the Udall family collection.

▶ *University students Lee Webb and Stewart
Udall were photographed by a Tucson street
photographer shortly before they married.*
Courtesy Stewart Udall.

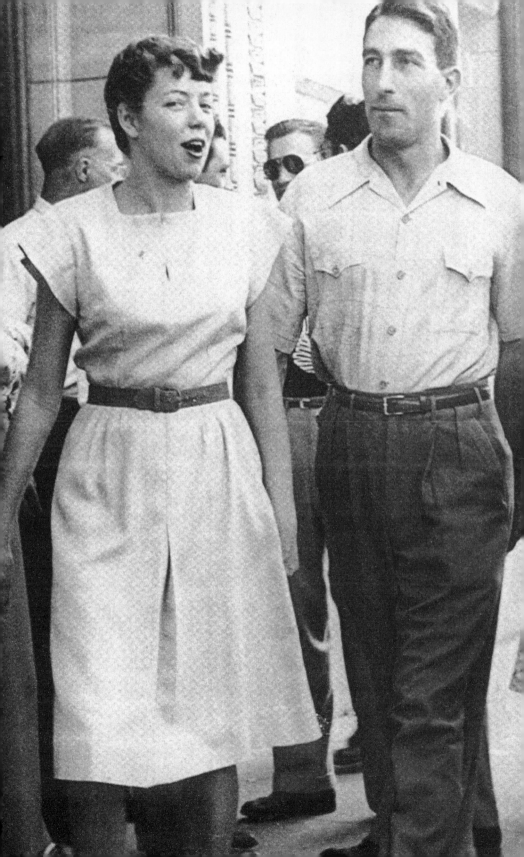

A formal portrait of Ermalee ("Lee") Webb Udall. Courtesy Stewart Udall.

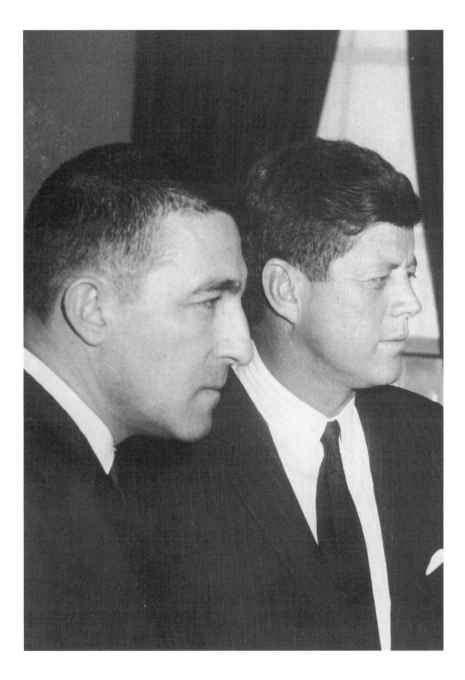

John F. Kennedy and Stewart L. Udall in January 1961. Author's collection.

Lee Udall and Stewart (partially hidden) in the Kennedy inaugural parade, January 20, 1961. Courtesy Stewart Udall.

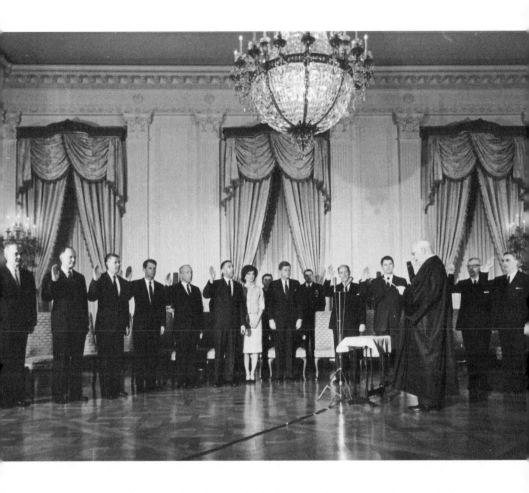

The swearing-in of the Kennedy Cabinet, with Chief Justice Earl Warren presiding. First Lady Jacqueline Kennedy stood between Udall and the president. AUTHOR'S COLLECTION.

▸ Following two pages: *Arizona friends donated large photographs of the Southwest for Secretary Udall's large office, which he described as his "basketball court." Left to right: L. Boyd Finch, confidential assistant to the secretary; T. Sutton Jett, National Capital Parks/National Park Service; Marvin Cohen, special assistant to the Interior Department solicitor; Secretary Udall; Herschel Schooley, departmental director of information.* AUTHOR'S COLLECTION.

The private dining room of the secretary. Udall is being served by dining-room steward Del. Undersecretary James K. Carr (in glasses) is to Udall's left. The author (in glasses, head tilted) is between Deputy Assistant Secretary Robert Paul and Orren Beaty, Jr., the assistant to the secretary (at the foot of the table). National Park Service photo by Abbie Rowe.

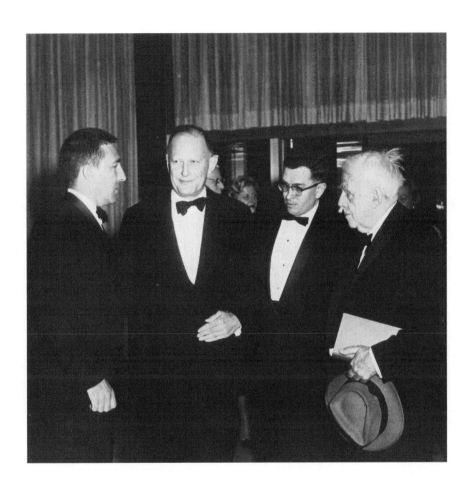

"An Evening with Robert Frost," May 1, 1961. Pictured are Secretary Udall, Treasury Secretary Douglas Dillon, the author, and Frost (with his fedora). National Park Service photo by Abbie Rowe. AUTHOR'S COLLECTION.

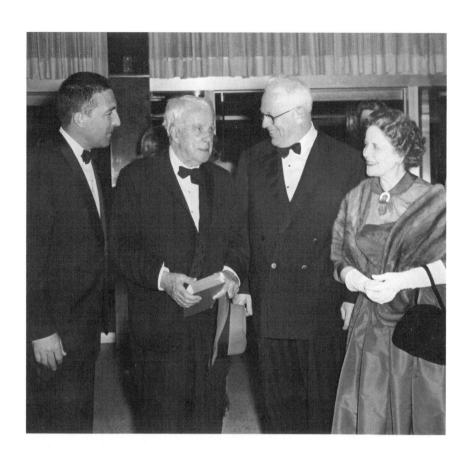

Stewart Udall and Robert Frost greeted Chief Justice Earl Warren and his wife, Nina Warren, at Frost's "Evening." National Park Service photo by Abbie Rowe.
Courtesy Special Collections, University of Arizona Library.

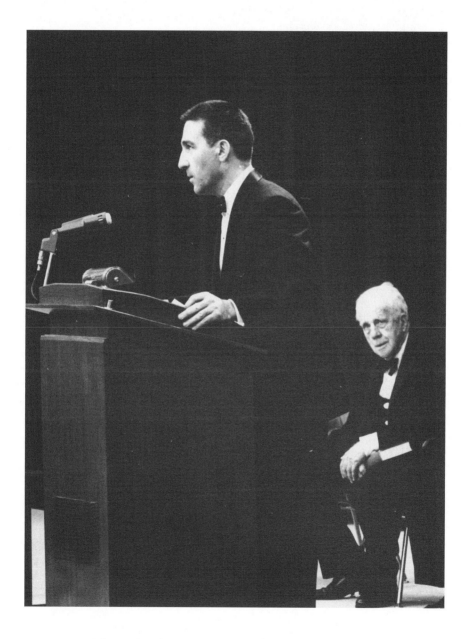

Stewart Udall opened the first "Evening" program of the President's Cabinet Artist Series.

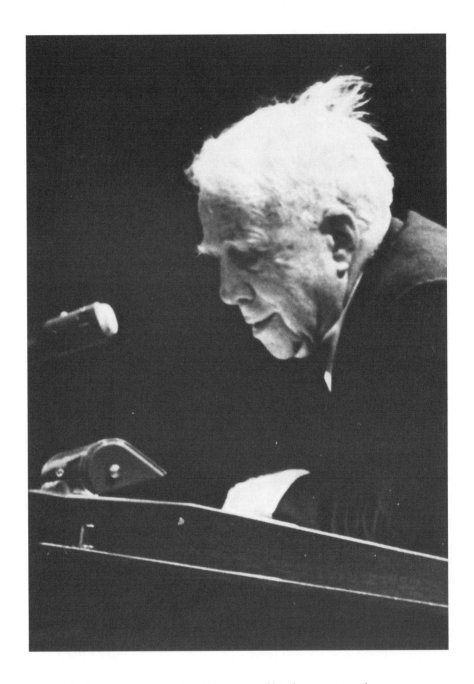

At the lectern, Robert Frost shared his poems and his pleasure. National Park Service photo by Abbie Rowe. COURTESY STEWART UDALL.

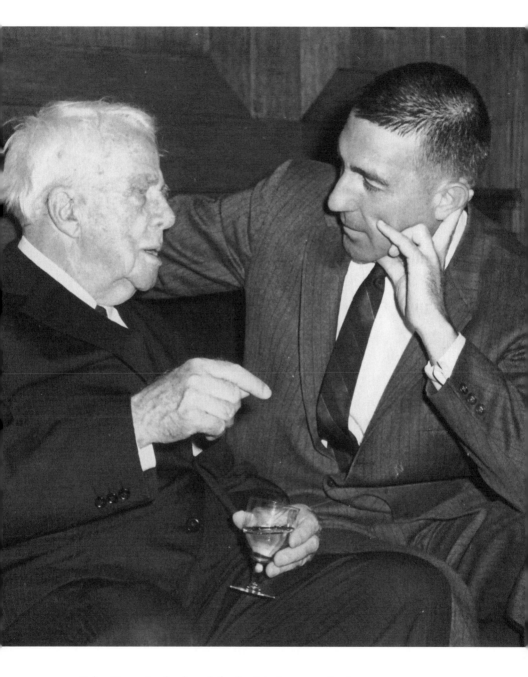

Robert Frost enjoyed a sherry before lunch in the secretary's private dining room. COURTESY STEWART UDALL.

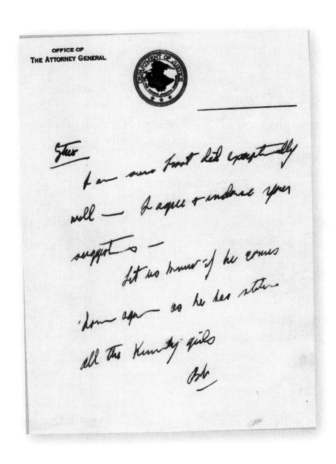

Robert Kennedy's note to Stewart Udall about
"the Kennedy girls." COURTESY STEWART UDALL.

Chapter 6

"Like Rosencrantz and Guildenstern"

IN THE SUMMER OF 1962, Udall once again sponsored Frost for an event that proved to be another lifetime highlight for the elderly poet. Stewart began plans for travel with electric power specialists from his own and other agencies to inspect Russian advances in hydroelectric generation and long-distance transmission. The Udalls invited Soviet ambassador Anatoly Dobrynin and his wife, Irina, to dine at Crest Lane with Frost, and the evening produced "a piquant exchange," as Stewart put it, about the rivalry between the two nations. Frost remarked that he would like to suggest to the Russian people "a magnanimous rivalry"—intellectual, creative, and athletic. "I impulsively proposed," Stewart recalls, "that Frost accompany me to Russia and explore his ideas with Soviet poets and writers." Dobrynin warmed to the idea, but the old poet wondered if he "was up to it." A few days later, though, Frost told Udall "he would make the trip if the president wanted him to go." He declared, "This becomes brotherly between us. I shouldn't be too sure of myself in Russia without you."[1]

Udall persuaded Kennedy to ask Frost to make the journey. Together Frost and Udall flew to Russia. When the Americans arrived at the Moscow airport a group of Soviet intellectuals, including the rising young poet Yevgeny Yevtushenko, greeted Frost. While Udall and the engineers flew on to inspect power facilities in Siberia, Frost remained in the city for literary events. He set his mind on speaking with "the great man," Premier Nikita Khrushchev. Stewart recalls that "I did not envision that either of us would be invited to confer with Khrushchev." If Udall was invited to meet the premier, he would be the first Kennedy cabinet member to do so. While Udall was in Siberia, Frost slogged through a demanding

schedule of readings and dinners in Moscow, all the while impatiently hoping to hear from Khrushchev.

Unexpectedly, the Soviet leader invited Udall to fly to his Black Sea dacha at Petsunda (Gagra), Georgia. There on September 6, 1962, the two talked at length and swam in the Black Sea before a several-course luncheon that included toasts between each course—all in all a very congenial time. Frost was invited to meet the premier there on the next day. When the poet awoke that next morning he felt sick, but, determined not to miss his opportunity, endured the three-hour flight. Stewart was not with him. On landing, Frost was hastened to a guesthouse to eat before traveling on to Khrushchev's country house, twenty minutes away. But, he collapsed on a bed. Khrushchev sent his personal physician, who found that Frost was simply worn out. Then the unexpected happened: the premier came to Frost. He walked into Frost's room and pulled up a bedside chair while the disheveled old poet put on socks and shoes and sat on the bed with his legs dangling over the side. Frost praised the premier's promotion of Russian poetry and stated his hopes for an East-West understanding. There was frank discussion of differences, but the meeting was cordial. After an hour-and-a-half, Khrushchev bid farewell, declaring, "It is a pleasure to have met such a famous poet." After his departure, Frost dropped back on the bed, saying to Franklin D. Reeve, his interpreter, "Well, we did it, didn't we?" Years later, Udall told a writer, "If Frost had had the chance, at that moment, of winning the Nobel Prize or talking to Khrushchev, he would have chosen to talk and forget the prize."[2]

Despite that memorable day, Frost's trip ended on a bitter note. As Stewart tells it, "Frost's adventure should have concluded on a positive note . . . a visit to Washington and a quiet report to the president. Unfortunately, that denouement was not to be." On landing at New York after eighteen hours in transit, Frost made what Udall calls "an unfortunate slip," telling reporters that Khrushchev "thought that we're too liberal to fight." Stewart knew Frost had used the phrase many times in teasing acquaintances, and believed that Frost had "put words in Khrushchev's mouth."

The statement stung Kennedy when he read it in the press. When Udall came to report, "the first question he fired at me was 'Why did he have to say that?'" The president reacted by ignoring Frost; he never again spoke with him. "That was Kennedy's way when he was angry," Stewart explains.[3]

Stewart's initiative had generated two meetings with the Soviet leader that had an international significance that he recognized only later. "I was puzzled," Udall recalls, "by the long hours [Khrushchev] spent visiting with the two of us." Six weeks after the visits, on October 21, Kennedy announced that the Russians were building missile sites in Cuba, and Udall "realized that the poet and I, like Rosencrantz and Guildenstern, had innocently walked onto a stage where a great struggle would soon occur."

The Soviets' decision to place missiles in Cuba had been made months before and "our appearance offered [Khrushchev] an opportunity to reassure President Kennedy that he was rational by talking earnestly about peaceful competition with his friends." Udall deemed it "a fascinating overlap of events" that occurred during that October week of crisis. On the same day that Kennedy revealed the Soviet-Cuban conspiracy, Yevtushenko's daring new poem calling for vigilance against the return of Stalinism, "The Heirs of Stalin," appeared in *Pravda*, the Communist party's official newspaper. And, within the week, the party's magazine published Aleksandr Solzhenitsyn's *One Day in the Life of Ivan Denisovich*. Udall believes the timing was not by chance. Khrushchev, on a political knife-edge, was brandishing a sword to satisfy part of his constituency while opening the way for changes that would please another element in his nation. Shrewdly, Khrushchev sensed that he *needed* to meet with the American cabinet member and the venerable poet. As a political veteran, Udall recognized that the premier "was using a Russian version of 'poetry-and-power' to push his program of political reform."

In what may have been another tactical move by the Soviet government, the Bolshoi Ballet came to Washington for performances in November 1962. Stewart and Lee were invited to an intimate dinner with President and Mrs. Kennedy in the White House living quarters, along with career diplomat Llewellyn Thompson and his wife, Jane. Thompson had been the U.S. ambassador to the Soviet Union and soon would again fill that post. After the private dinner, the three couples attended the opening performance of the Bolshoi at the Capitol Theater.[4]

Throughout the fall and into winter, Kennedy's shunning of Frost continued. Udall tried to explain to the president the circumstances of Frost's offhand remark, but even when the poet was hospitalized in Boston a few weeks later, Kennedy never called or sent flowers or a note. Stewart remembers, however, that Robert and Ethel Kennedy did send flowers to the hospital room. The

president's cold shoulder was a sad turn for Frost because, in the words of one journalist, "It was the [earlier] presidential attention that converted Frost from the important poet known by the literary few to the important public figure."[5]

Robert Frost died on January 20, 1963, a cherished figure known around the world. How many other poets had talked to powerful political figures the way he had, face-to-face with the heads of the world's two dominant regimes—all within a six-month period? Frost's life, thanks to Stewart and Lee Udall, and to John F. Kennedy, "ended in a dream of power." Udall, guardian angel of Frost's triumphal years, wrote later, "I will always believe Frost's association with Kennedy's Washington kept him alive many extra months. Almost to the end he retained a young person's capacity to summon extra power for important occasions like conversations with Kennedy and Khrushchev."[6]

Nine months after Frost's death, Kennedy tried to atone for his shunning of the poet following Frost's return from Russia. The president accepted an invitation to speak at the October 26, 1963, groundbreaking for Amherst College's Robert Frost Library, and he asked Udall to fly with him on Air Force One to the western Massachusetts college. While en route to the event, Udall told the president that Frost's daughter Leslie was quite angry about Kennedy's avoidance of the poet since the Russian trip. Because Stewart feared that she might "make a scene," he explained, "[You may] see me wrestling on the ground with a woman." Kennedy replied, "We'll give you the benefit of the doubt, Stewart."[7]

Both Frost's good friend Archibald MacLeish and Kennedy were to speak (which Udall believed was a breach of protocol since presidents were not expected to share a platform). Speaking first, MacLeish assumed the persona of a squire of the Berkshires, predicting that "the people of this countryside . . . will remember for many, many years that a young and gallant president of the United States with the weight of history heavy upon his shoulders, somehow found time to come to our small corner of the world to talk of books and men and learning." He pointed out that Amherst would have "the first general library ever to be called for a poet in America."

"Not many years ago," MacLeish recalled, Frost had told Amherst friends, "Poems are speaking voices. And a poem that is hard to get rid of is a voice that is hard to get rid of." MacLeish observed that "literary reputation is a poor thing. . . . Frost will be praised and then neglected and then praised again like

all the others. . . . He wanted to go on being. And he has."

Both speeches that afternoon greatly affected Udall. "I just sat there on the stage; the two speeches back to back were the most eloquent, the best I ever heard." MacLeish was "so poetic, so elegiac." The president's speech that followed MacLeish's was, in Stewart's words, "Kennedy's Noblest Speech—the most majestic speech of his presidency." All in all, it was a great afternoon for speechifying.[8]

Kennedy described Frost as "one of the granite figures of our time" who "saw poetry as the means of saving power from itself."

> In honoring Robert Frost we therefore can pay honor to the deepest sources of our national strength. That strength takes many forms and the most obvious forms are not always the most significant. The men who create power make an indispensable contribution to the nation's greatness. But the men who question power make a contribution just as indispensable, especially when that questioning is disinterested. When power leads man toward arrogance, poetry reminds him of his limitations. . . . When power corrupts, poetry cleanses. . . . The artist . . . becomes the last champion of the individual mind and sensibility against an intrusive society and an officious state. . . . I look forward to an America which commands respect throughout the world not only for its strength but for its civilization as well.[9]

Senator Ted Kennedy gave Stewart a typewritten draft of the president's speech, evidently written by one of the president's assistants ("AS, jr." was at the top of the first page). It shows numerous changes made by hand to the text, presumably by the president. Kennedy knew the beauty of simple, direct language. One line in the typewritten draft that read originally, "When power intoxicates, poetry restores sobriety," was lined out and changed to "When power corrupts, poetry cleanses."[10]

Chapter 7

The Effects "Just Rippled Out"

As a result of the Udalls' dinner invitation to Frost and their "consultation" in 1959, much changed in Frost's life, and he welcomed every bit of it. He became a public man, known internationally beyond the confines of the literary world, gaining fame and a place in history. For Stewart and Lee—and for the nation—the little dinner party brought consequences that none of the participants could have anticipated. Stewart marvels now at all that followed; the effects "just rippled out for several years." One such "ripple," the programs at the State Department auditorium, began transforming the national capital's culture and inspiring the nation. A journalist noted that Udall's "evenings with . . ." brought "praise from people all over the country as proof of America's cultural advancement. . . . It has given our country a new kind of prestige and has been a lift to our national pride."[1]

Metropolitan dailies carried articles about beatnik poets. When Louis Untermeyer was interviewed about them, he said that he might read the beatnik poetry only once but, in the poets' defense, there probably were just as great a percentage of "eccentrics" among bankers as among poets. The *New York Herald-Tribune* played the story above its page-one nameplate, accompanied by illustrations of Frost, Milton, Sandburg, and Chaucer—supporting Untermeyer's thesis that poets were not "removed from ordinary life." Untermeyer, somewhat amazed at the prominent placement of the article, sent a clipping to Udall along with a brief note: "I quote from a telegram sent by M. Lincoln Schuster, of Simon & Schuster [book publishing firm] . . . 'Culture is sure to thrive in a country when statements by a poet make top news on the front page of a metropolitan daily.'" Later, in a story headed "MacLeish Sees Social Commitment in

Poetry on the Rise," a *New York Times* article quoted Archibald MacLeish: "Poetry is going to become an increasingly vital part of contemporary life. . . . Poetry should deal with public issues and the human heart. And the human heart is a social organ, not just a private one." Stewart saved both articles.[2]

When a cabinet member is asked to read poetry at a suburban choral concert it is further evidence that there is a change in the air. The Montgomery County (Maryland) Oratorio Society invited Udall to take part in a program featuring composer Randall Thompson's "Frostiana," a work based on seven of Frost's verses. Between each musical segment of the composition, Udall read the particular poem that had inspired Thompson.[3]

Udall inquired of T. S. Eliot whether he could appear at a cabinet-sponsored affair during a forthcoming American visit. From London, the expatriate American poet replied cordially that he would not have an opportunity to visit Washington.[4]

Poetry continued to gain recognition, and in 1968 Congress changed the title of the Poetry Consultant to the Library of Congress, creating the first Poet Laureate of the United States. The initial honor went to Robert Penn Warren.

In advance of the next Artist Series event, Udall wrote to the presidents of nine nearby institutions of higher learning, offering tickets for six students from each school, the selections to be made by the school. Udall wrote that formal dress would not be needed: "Suitable nonformal attire will be acceptable for the students." The chosen institutions were: American University, Catholic University of America, Dumbarton College, Gallaudet College, George Washington University, Georgetown University, Howard University, Trinity College, and the University of Maryland. Student invitations continued for most of the following Artist Series events.[5]

The students may not have been aware that at the January 7, 1963, program among the other guests were two prominent grande dames, Rose Kennedy, the president's mother, and Alice Roosevelt Longworth, President Theodore Rooosevelt's daughter. The attraction was Her Majesty's Royal Shakespeare Company presenting *The Hollow Crown*, a sampler of music, poetry, letters, and other generally light-hearted depictions of the foibles of British monarchs from William the Conqueror through Victoria. The title derived from a passage in Shakespeare's *Richard II*: "For God's sake, let us sit upon the ground and tell sad stories of the death of kings . . . for within the hollow crown that

rounds the mortal temples of a king keeps Death his court; there the antic sits, scoffing his state and grinning at his pomp."

The production was the premiere American appearance of the Stratford-upon-Avon and London-based company. The printed program explained that *"The Hollow Crown* comes to America as an ambassador" for the company's planned visit to the United States with a full-scale repertory in 1964. Among the evening's cast were Max Adrian, John Barton, Paul Hardwick, and Dorothy Tutin, with music director Brian Priestman.

A reception at the British embassy followed the performance. The embassy is an impressive structure on Massachusetts Avenue's "embassy row." We Finches drove through the entrance gates—between two pillars, one topped with a stone lion, the other with a unicorn—and were greeted under the porte-cochere by tuxedoed valets who took our five-year-old Plymouth to be parked somewhere amidst the Cadillacs and other vehicles of that ilk. When we entered the stately ballroom, the Udalls were busy greeting and being greeted. From a less-prominent location Polly and I became wallflowers, overwhelmed by the ambiance but enjoying the scene. What we most remember now is how male guests clustered around Miss Tutin. Adlai Stevenson seemed especially attracted to the pretty young actress. Or, did the attraction run the other way?[6]

To continue the international atmosphere of the cabinet-sponsored evenings, the next featured artist was classical guitarist Andrés Segovia. Following Segovia's March 18, 1963, recital at the State Department auditorium, the Spanish ambassador hosted a reception at the embassy. The party probably was as interesting for Stewart and Lee as it was for us; we all gained an insight into the marriage of the Segovias. In the embassy's tiled indoor patio—suggestive of what might be found in a home in Spain—the stout, sedate artist sat patiently on a wooden chair while his wife filled his pipe with tobacco from her purse, tamped down, and lit the tobacco, and took a few puffs before handing him the pipe. After that ritual, Segovia entertained the circle of fortunate guests with more music, in a much more intimate setting than that earlier in the evening.[7]

Next, Chilean ambassador Guterriez-Olivas gained Udall's support for his nation's "Image of Chile," a multimedia festival of Chilean culture. Secretaries Dean Rusk and Willard Wirtz and the ambassador presided at two Artist Series events at State's auditorium. At the first, on September 22, Leonard

Bernstein lectured on Chilean arts prior to a recital of the poems of Gabiela Mistral and Pablo Neruda by actress Felicia Montealegre (Mrs. Bernstein). The evening concluded with colonial music by vocalists and instrumentalists of the Ancient Music Group of the Catholic University of Chile. Afterward, guests socialized under a large tent at the embassy.

A week later, again at the State Department auditorium, Chilean pianist Claudio Arrau presented an all-Beethoven recital—five sonatas including the "Moonlight" and the "Appassionata." One reviewer noted, "Arrau said he is lately very taken with Beethoven and liked to give a whole evening of his music." Emphasizing the perceived importance of the cabinet event, Arrau broke off a European concert tour to appear that one night in Washington; he flew back to Europe the next day. The press continued to report on the Cabinet Evenings, evidence of the capital's sustained interest in the arts.[8]

The success of the Cabinet Artist Series, modest in scale as it was, emphasized the scarcity of performance venues in Washington and helped induce President Kennedy to open a major campaign drive in October 1963 for private funds to construct a National Cultural Center on the banks of the Potomac not far from the Lincoln Memorial. Authorizing legislation in 1958 had called for private financing, and donations were slow in coming; five years later, the facility, as author Brendan Gill wrote, "existed on paper, but without a penny in the till." Kennedy appealed to national pride, declaring, "The nations of the world have their great and beautiful centers for the performing arts, but here in the world's greatest capital we have nothing."[9]

On November 1 violinist David Oistrakh opened a Cabinet Artist Series program with compositions by Bach, Schubert, and Brahms, followed by works by Russian composers, Karol Szymanowski's "Nocturne and Tarantella, Opus 28," and Dmitri Shostakovich's "Three Fantastic Dances." A reception followed at the Soviet embassy on Sixteenth Street. Guests entered through a long, well-lighted hallway lined on both sides with floor-to-ceiling mirrors (I wondered, "Are they one-way glass?) to an ornate stairway leading upward to the second-floor ballroom. From that level the stairs continued upward, but an impassive, burly figure in a tux sat on a straight chair squarely in the middle of the base of the upper stairway. The message was clear: This far and no farther. It was a cold night outside—and initially a bit "chilly" on the inside too—but the superb vodka at the Soviet embassy's postconcert reception warmed the guests.[10]

Chapter 8

"Disappear for a While and Write a Book"

STEWART TOLD the *New York Post* in December 1960, after Kennedy's announcement that he would become Secretary of the Interior, that he had done some magazine writing and "in my new job I hope to do more writing, as well as speaking. I think that is very important. . . . A cabinet officer has a responsibility to educate the public." He soon realized that he would need help, for requests for articles poured in. Henry Romney, given leave by *Sports Illustrated*, joined the staff to produce drafts that Stewart could rewrite in his own direct style. Somehow, Romney did not fit in, but he left on amiable terms, later thanking Udall for the "happy times." Stewart approached Pulitzer Prize–winning New Mexico author Paul Horgan, but the timing was wrong. Horgan had just moved to Connecticut to join the faculty at Wesleyan.[1]

In the fall of 1961, Stewart persuaded Wallace Stegner, a future Pulitzer Prize–winner, to join his staff. That had not been easy, for Stegner was a busy man, but their teamwork became—forgive the cliché—a marriage made in heaven.

With knowledge of the wild, fragile Colorado Plateau gained from research for his biography of explorer-scientist John Wesley Powell, Stanford creative writing professor Stegner became an advocate for preservation of the scenic but arid lands where Colorado, Utah, Arizona, and New Mexico touch. He created a rallying cry for advocates of wilderness protection in a 1960 letter, which he concluded with eloquence: "We simply need that wild country available to us, even if we never do more than drive to its edge and look in. For it can be a means of reassuring ourselves of our sanity as creatures, a part of the geography of hope." *The geography of hope*—that resonated with Udall.

When Kennedy announced his choice of Udall for Secretary of the Interior, a man for whom the Four Corners region was home, Stegner rejoiced and sent congratulations and a copy of his *Beyond the Hundredth Meridian*. Udall knew the book, but several phone calls were needed before Stegner, deeply involved in two writing projects, agreed to set aside four months to serve as the secretary's eyes and ears on park options in the Four Corners. He trooped across the expanse by jeep and horseback with two Park Service men and a few others savvy about the area. His report began the conversion of Arches and Capitol Reef National Monuments to national parks, and led to the creation of Canyonlands National Park. When he reported to Washington that fall Stegner became Udall's literary aide-de-camp, the first of an energetic succession of talented writing assistants.[2]

Udall's editor friend Al Josephy observed that Udall "enjoyed the notion of having a 'writer in residence,' someone who was only temporarily a member of the government and from whom he could seek reactions and advice on all subjects." Beginning with Stegner, Udall set a pattern of involving his writers in almost every aspect of the office: "I didn't just bring people in and stick them off in a corner and tell them to write speeches or something. I would let them be involved in meetings and let them do memos and let them throw out ideas. . . . I'd have a lunch every day for my top people and I'd have him [Stegner, and his successors] to the lunch. And he would talk along about issues and things that were happening. . . . Stegner is not a bashful person."

Udall's informal dining-room luncheons encouraged conversations of substance. Among the guests were Frost's devoted friend Untermeyer while he was the Library of Congress poetry consultant for 1961–63, Charles Lindbergh, David Brower, Vincent Price, Saul Bellow, scientists, journalists, politicians, and more. One writer stated that the dining room was becoming "a way station for visiting intellectuals." About a dozen persons could be seated at its rectangular table. Del, the Filipino cook-waiter-dishwasher, bought the main ingredients each morning, and the grocery bill was divided equally among the diners later, with Udall paying for his guests and himself. To fill the table, Udall's secretariat (under secretary and assistant secretaries) and personal staff were invited to share the meal, the talk, and their portion of the bill, an occasional privilege that I enjoyed.[3]

In September 1961, Stewart and Lee visited Frost at his home, the Homer Noble Farm in Ripton, Vermont. After returning home, Stewart dashed

off a note to Frost: "The more I think about [it] the more I like the idea of a Robert Frost Memorial Park as a major addition to the National Park System. I expect to send up a 'trial balloon' in Vermont on October 6 when I make an appearance at Barre. We will get an idea then as to the receptiveness of the Vermont people." Stegner, familiar with the area because of its proximity to the site of the Bread Loaf Writer's Conferences, many of which he had attended, offered detailed suggestions for the park, saying it ought to be "scrupulously simple and unpretentious." Despite further public relations efforts, the proposal for a memorial (as a national park operation) had to be shelved because of local antigovernment opposition. Today, Middlebury College administers the farm as a Frost memorial.[4]

Full of ideas, Udall had Stegner explore the feasibility of a documentary motion picture on Frost, and he also considered documentaries on the national parks, and on the American land. Stegner consulted with Pare Lorentz, FDR's New Deal filmmaker who guided *The Plow that Broke the Plains* and *The River*. Lorentz liked some of Udall's concepts, but he was not available to take on any of the possibilities. Nothing further developed.[5]

The press persisted in scrutinizing Udall's every move, and Stewart made more than his share of publicized bloopers. As Stegner's biographer, Jackson J. Benson, tells it, Udall asked Stegner, "How do you shake this sort of thing?" In reply, Benson reports, Stegner suggested doing "what outlaws used to do," riding their horses up a stream to lose the posse. "Just lower your profile, disappear for a while, and write a book."

Udall: "About what?"

Stegner: "About what you are doing here and what you think needs to be done."

For Stewart, disappearing for a while was unlikely, but writing a book struck sparks.

It was the birth of *The Quiet Crisis*.[6]

During his final weeks on the staff in late 1961, Stegner spent days at the Library of Congress doing research. Early mornings, when Udall was in Washington, Stegner would stride into the suite bearing sheaves of paper, and he and Udall would huddle in the back parlor, sharing ideas and reviewing what Stegner was pulling together. In essence, the professor was instructing the secretary in effective writing. When Stegner returned to Stanford that December he left behind an outline for the book, suggestions for further

research, and a draft chapter. "Start with the Indians," he advised, and Stewart did so. For the next year and a half, Stegner reviewed chapter drafts that Udall sent him, and he helped find writing assistants. Further, he and his wife Mary became dear friends with Stewart and Lee, a connection that continued into old age.[7]

Even before Stegner's arrival in Washington, a young woman from Seattle and a Mount Holyoke graduate—Sharon F. (Mrs. Harry) Francis—began helping with the writing. An honors program on wilderness legislation had prompted her to write for conservation magazines. Her writing had impressed Stewart, and he asked to meet her. She arrived for an interview with Udall one hectic day before the inauguration. "He had time to ask me one question: 'Those North Cascades, should they be a national park?' I burbled about the home mountains that had been my lifelong inspiration, but he got another call, and I didn't think he heard the answer." A few days later one of Udall's aides phoned, asking "Where are you? We're starting to work."

Francis worked on articles with Stewart for his signature. She recalls of that time:

> He had a fine sense of words . . . an economy of statement. . . . Often he took a whole paragraph of my exposition and turned it into a single sentence that said everything. On *The Quiet Crisis*, I . . . worked with all the consultants, Gilliam, Stegner, Josephy, etc., drafting chapters, doing research. It was an iterative process in which every draft went to Stewart and then came back to me, or to me and the consultant at the same time. Stewart usually cut verbiage, and added his own pithy realizations. It was hard to keep up with him. I'd think I had done a whopping good piece of research on Francis Parkman or George Perkins Marsh, and put it into Stewartese, only to have him bounce it back, with his own research and insights. That was a wonderful time. I was too naive to realize what a literary potentate Wally [Stegner] was. He was just Wally, and we debated the significance of bits of history.[8]

She handled other duties; modestly, she now calls them "soft." With an idea spawned in Stewart's mind, she arranged a commemoration of Henry David Thoreau for May 11, 1962, the one-hundredth anniversary of his death. It was a simple afternoon gathering with no food or cocktails, held in the secluded Dumbarton Oaks park in Georgetown and cosponsored with the Wilderness

Society. For a brief forty minutes the glen sparkled with remarks by Frost, Justice William O. Douglas, Howard Zahniser of the Wilderness Society, and Udall—respectively, the nation's cherished poet, a Supreme Court justice, the dedicated advocate for wilderness preservation, and a cabinet member—all paying honor to the memory of a long-dead author-naturalist. It was a gathering not likely to occur in Washington today.[9]

Afterward, Frost and Udall walked out of the park together, and as they walked the old man shared some thoughts and a surprising secret. When Stewart returned to his office he wrote himself a note: "Robert, during our walk in the woods at Dumbarton Oaks, said too many of the Library of Congress people were 'precious unto themselves'– i e [sic] made no contribution to the expansion of the arts. I've never been to Walden[,] R.F. said, 'I couldn't bear it to go.'"[10]

Stegner's aura lingered in the secretary's suite; two of his former Stanford students, endorsed by the master, Don Moser and Harold Gilliam, came in his wake. Moser arrived first; although he recently had joined the staff of *Life*, the magazine gave him leave to serve Udall. Within three months after Stegner returned west, drafts were under way on fourteen chapters of Udall's projected book. Despite much rewriting, most drafts stayed the course set by Stegner. For the initial drafts, Udall, Francis, and Moser were joined by anthropologist James Officer (brought from Tucson by Udall) of the Indian Bureau, Geological Survey hydrologist Luna Leopold (a son of pioneer conservationist Aldo Leopold), forester Charles Stoddard of the secretary's resources program staff, and Tucson conservationist Joe Carithers, who later became superintendent of Big Bend National Park. Recently, I asked Stewart whether, in having more than one person work on the same chapter, he was consciously taking a leaf from Franklin Roosevelt's practice of duplicate assignments. "No, not consciously, but it struck me as a good way to share insights and ideas. Not a bad approach when you are as busy as I was."[11]

Stewart edited with scissors and Scotch tape, inserting text handwritten on yellow, legal-size paper. Much of his fine-tuning occurred early mornings in the back parlor of his suite. One of his writing aides, Harold Gilliam, recalls that Udall's "driving energy" enabled him to work "at full throttle fourteen to seventeen hours a day." On occasion, Stewart—seated in his wooden "New Frontier" rocking chair—would gather "my people" in a half-circle before his fireplace to thrash out approaches to the chapter under study.[12]

Udall believes that during his cabinet years his writer-in-residence idea was "the best thing I ever did, because I was studying my job." More than one person was gaining an education; his writers benefited from Udall's open door, free-wheeling luncheon conversations and travel opportunities. Don Moser remembers, "To give me a sense of the country, Stewart sent me to Grand Teton and Glacier National Parks to see what was going on." He adds, "Who was I to object?" In recalling those days, he comments, "It was rather amusing. I had a wonderful time reading about the American West. I had a key to the department library [a fertile source for *Quiet Crisis* material] and a key to the secretary's private elevator. I would draft a chapter with narrative, relevant detail, and yarn spinning. Stew would revise what I had done. I drafted a couple of speeches; Stewart would ignore them and say what he wanted."

Moser remembers other aspects of life with Udall illustrative of the informality that often characterized the secretary. "One noon we took the [chauffeured] limousine to a place up on Pennsylvania Avenue [five or six blocks distant] to have some hamburgers." Moser also tells about the day when Justice Douglas, Illinois senator Paul Douglas, and Udall led several score walkers along the towpath of the C & O Canal on the Maryland side of the Potomac, demonstrating for preservation of the historic waterway. Near Little Falls a heavy rainstorm hit, and the demonstrators ran to the porch of the Old Anglers Inn where they huddled, dripping water. The proprietor's wife appeared and, in a voice that meant business, ordered the justice, the senator, the secretary, and all their well-soaked band off her porch. The incident made news.[13]

As *Quiet Crisis* began to take shape, Californian Harold Gilliam, fresh from publication of his *Island in Time: The Point Reyes Peninsula*, succeeded Moser in the fall of 1962. He came for a three-month term "which turned out to be nearly a year." After his Udall experience, Gilliam returned to the *San Francisco Chronicle*. In 1969 when Walter Hickel succeeded Udall as the secretary, Gilliam—acknowledging his possible bias—saluted Udall in the pages of the *Sunday Examiner and Chronicle*: "Almost alone among his contemporaries in Washington, Udall has been able to express eloquently a sense of high purpose, a deep awareness of history and a long-range view of where we are going.... [He is] the chief prophet of a new concept of the total environment."[14]

A later recruit was James Reston, Jr. Distinguished newsman James "Scottie" Reston and his wife were friends of the Udalls, and Stewart learned

from them that their son Jim was interested in a writing career. After his college graduation in 1963, Jim was on a Mackenzie River workboat in the Yukon when he got word that the Secretary of the Interior would like him to look into a controversy at Mount McKinley (now Denali) National Park in Alaska—several hundred miles distant. Reston hitchhiked from Dawson City, Canada, to the Alaskan park. He was instructed to look at two developments that had some purists up in arms—an unpaved narrow road into the park and interpretive signs at a beaver pond—and prepare a written report to Udall. Following that chore, Reston joined Udall's staff in Washington where he marveled at the privileges he enjoyed. He remembers that Udall "gave me free rein to attend any Secretarial meetings that interested me. . . . He was so open. Awe took over in my mind . . . a kind of hero worship . . . to be so close to power." Reston admits, however, that Udall once "immensely disappointed" him. Jim had drafted a speech for Stewart to deliver to a black audience—"it excited me a lot to write it"—but he remembers Udall's delivery that day as uninspired, flat. In contrast, he recalls substituting for Udall at a White House meeting and sitting next to President Johnson: "I was utterly awed." Like Moser, Stegner, and others, Reston cherishes the memory of the dining room discussions.[15]

One other *Quiet Crisis* contributor was Al Josephy, senior editor of the book division of *American Heritage* magazine, who coordinated the selection of photographs for the book. Josephy also shared insights as work on the book advanced, twice joining Stewart for outings in the Four Corners backcountry.[16]

As each *Quiet Crisis* chapter neared completion, Udall would mail the text to Stegner. Among the collected Udall papers, letters from "Wally" to "Stewart" (never "Stew") show how closely Stegner followed the book's progress:

[August 25, 1962] I think you've got a good chunk of a book. . . . [The] theme of a growing land ethic has never been put together in quite this way, with quite this clarity and emphasis. . . . I think my marginalia are self-explanatory, but I might summarize. . . . You don't date often enough and steadily enough. . . . A reader needs constant reference points so that he doesn't get lost. . . . [In] the Emerson-Parkman-Thoreau [chapter], the discourse stays too consistently on an abstract level. . . . I am astonished at how well this all does read,

considering the hands that have been in it. You do a good job of putting your own mark on it.

[June 7, 1963] [The book's] big and unique strength ought to be that it comes from you, it flows out of the source of political power, and therefore has the authority and the hopefulness of practical accomplishment that a lot of conservation writing lacks. We can sing all we want to, but when a man with his hand on the lever sings the same song, something new has been added.

[June 15, 1963] Maybe I'm wrong to be suspicious of the hortatory tone, but I am. I believe that some of my suggestions on previous chapters had the intention of reducing the preachment. You've still got a little of the Mormon elder in you, and not every audience is as willing to hold still for counsel as the Saints are. Logical argument and concrete proof is generally better than adjuration. But you're not talking in tongues in this book. It all needs saying, with all the authority you will give it.[17]

The book's final proofs were ready in September 1963, with a John F. Kennedy introduction. Stewart made a final addition, a dedication: "For Lee." The book appeared in bookstores early in November 1963.[18]

"A Fine and Loving Book"

QUIET CRISIS TELLS of the relationship of the American people to the American land, examining their evolving concepts as shown by the actions and words of representative individuals. Chapter 1, "The Land Wisdom of the Indians," is an exception, for no individual is featured. Thomas Jefferson is central to chapter 2, "The Birth of a Land Policy." Then comes "The White Indians"—Daniel Boone, Jedediah Smith, and the Mountain Men. On it goes: Thoreau and the naturalists; George Perkins Marsh, Carl Schurz, and John Wesley Powell; Gifford Pinchot, John Muir, Frederick Law Olmstead, and more. A short final chapter offers "Notes on a Land Ethic for Tomorrow." Stewart and his aides drew from an array of American thinkers. Epigrams that open each chapter are quotations from Frost, Stephen Vincent Benet, MacLeish, Marsh, Stegner, Pinchot, Sandburg, Theodore Roosevelt, Thoreau, Thomas Wolfe, Kennedy, Aldo Leopold, and one non-American, D. H. Lawrence writing in Taos, New Mexico. Also quoted in the text are Parkman, Emerson, Whitman, Lindsay, Mark Twain, William Allen White, Franklin D. Roosevelt, and Bernard ("Benny") De Voto.

An editor summarized Udall's message in an eight-line blurb on the front flap of the book jacket: "America today stands poised on a pinnacle of wealth and power, yet we live in a land of vanishing beauty, of increasing ugliness, of shrinking open space, and of an over-all environment that is diminished daily by pollution and noise and blight. This, in brief, is the quiet conservation crisis of the 1960's."[1]

Earlier that fall of 1963, Josephy came to Washington, where he joined Udall's in-house writing team. He recalls, "It was a

fascinating assignment, for Udall kept me close to him all day, sitting in on most meetings." He was aboard a presidential plane with Stewart and Lee and five other members of the cabinet flying for cabinet-level talks in Japan when word of President Kennedy's death reached them as they were high above the Pacific. On that flight, as Udall recalls it now, "there was a ticker tape receiver [teletype machine] on the plane and we were over the Pacific when the news of Kennedy being shot was received." The message was passed around the cabin, reaching Udall last. "I just put it in my case and kept it." The plane turned back. America, stunned, seemingly came to a standstill.

Although he had been on Stewart's staff only a short time, Josephy returned to New York. The news brought an end to Josephy's work with Udall although their close friendship continued. For Udall the unforeseen ascendancy of Lyndon Johnson to the presidency brought a period of uncertainty; Udall's future in the presidential cabinet was in doubt.[2]

Despite the national trauma, or perhaps a bit because of it, the book by Kennedy's Secretary of the Interior sold well. *Quiet Crisis* moved onto the *New York Times* best-seller list where it remained for several weeks, and it was nominated for a National Book Award. Praise came from many quarters, including one from a surprising source: violinist Yehudi Menuhin wrote Stewart from London that the book's message was "very close to my heart." The *Christian Science Monitor* called it "one of the best written volumes on the history and importance of the American conservation movement." The book's popular reception may have saved Udall's job.

Stegner wrote Udall, "It's a fine and loving book. . . . I am pleased and astonished at how you have been able to take the rough drafts or rough ideas of many different people and make them all your own. . . . One of the marks of your personal style is that things are boiled down to their essence. . . . Altogether, a splendid job."[3]

Most reviews were favorable:

- Brooks Atkinson of the *New York Times* wrote that it was "invaluable because of its informal chronicle of the relationship between America and the land from the beginning."
- Leonard Hall of the *St. Louis Globe-Democrat* called it "swiftly-paced, well-researched."

- Tim Renken of the *St. Louis Post-Dispatch* commented that it was "especially eloquent as a plea for the so-called wilderness areas."
- Miles A. Smith of *Publishers Weekly* declared it an "eloquent exhortation."
- Ed Ainsworth of the *Los Angeles Times* wrote, "I have fought the Department and some of its schemes personally and professionally, but in 'The Quiet Crisis,' Mr. Secretary, you and I are in total accord on conservation."
- Author Joseph Wood Krutch in the *New York Herald-Tribune*, and U.S. senator Gaylord Nelson (D., Wis.) in the *Washington Post*, provided favorable reviews, but the *Chicago Tribune* reviewer, Jerry Cowle, differed: "Just another compiled work of a government agency, a modern-day WPA writing project. [After chapter 1 and the "excellent" photographs] the interest goes straight down hill. It begins to read like the dullest sort of a textbook, heavy with borrowed quotes and allusions to earlier writers. It only confirms the truism that nothing great has ever been written by a committee."[4]

Udall's team of young writers moved on, finding publishing success. Moser has written six books and for many years edited *Smithsonian* magazine. During the many decades that Gilliam was the *San Francisco Chronicle's* environmental columnist, he published fifteen books dealing with the natural environment. Reston has produced more than a dozen works. After his return to New York City, Josephy remained with *American Heritage*, eventually moving up to the editor's chair; he penned still more books dealing with western history and earned the respect of academics in the field, becoming president of the Western History Association.

Stewart detailed Sharon Francis to Lady Bird Johnson after a magazine interview with the First Lady about junkyards, billboards, and other landscape blights resulted in a deluge of favorable correspondence. Sharon drafted replies to the letters and, Udall says, stayed on to help "turn the support of Lady Bird's ideas into a program," drafting Mrs. Johnson's speeches in her efforts to beautify America. Mrs. Francis later served in the Environmental Protection Agency, led a campaign against acid rain in New Hampshire, and became executive director of the Connecticut River Joint Commissions, for which she recently edited a book, *Proud to Live Here*.[5]

Later in his secretarial years, Udall's writers-in-residence included Henry "Hank" Bloomgarden, an author who also became a big winner in a national television quiz show; John McGinty, a White House Fellow assigned to Interior for a year; and Peter Matthiessen, whose wide-ranging writing career was in its infancy.[6]

Chapter 10

"All Meteors Sign the Sky Once— Only Once"

THE KENNEDY ASSASSINATION put a halt to many plans in Washington. The future of the President's Cabinet Artist Series was one of the minor concerns of the moment.

Stewart saved a Mark Shields column of the time that must have reflected his belief: "John Kennedy set and maintained a definite national mood and articulated definite public values. The mood was one of optimism and idealism.... Public service was honorable. ... We believed in ourselves and in our future." Ten years later, as Stewart reflected on Kennedy's life and death, he wrote sixteen lines of poetry entitled "On the Hillside at Arlington," ending with "Then why do we stir our griefs / or yearn for cancelled constellations / when we know all meteors / sign the sky once—only once?"[1]

That long, gray winter of 1963–64, a group of youngish men and women gathered for a memorial service at the grave in Arlington Cemetery. They were the members of the New Frontier Club, appointees of the Kennedy administration, advance-men, and other veterans of the 1960 campaign who dined twice monthly at the historic Occidental Café on Pennsylvania Avenue. The club members, inspired by Udall's Artist Series, had initiated their version of artist evenings at State's auditorium in 1962 with Ethel Kennedy, Robert's wife, as the honorary chairman. Over several months the club presented guitarist Charlie Byrd and his Trio, the Ethel Butler Dance Company, and flamenco guitarist Juan Serrano, two Air Force musical groups—"The Singing Sergeants" and "The Airmen of Note" dance band—and vocal recording artists "Three Young Men from Montana." The club dissolved after the memorial service at the president's grave. For the junior New Frontiersmen, John F. Kennedy's New Frontier had closed.[2]

After an appropriate time had passed, Stewart wrote the new First Lady, reviewing the past programs and inviting Mrs. Johnson to assume the honorary chairmanship of the President's Cabinet Artist Series. He suggested that more international artists be invited, naming singers Joan Sutherland from Australia and Birgit Nilsson of Sweden, British actor Sir John Gielgud, Irish actor Micheál McLiammóir with his presentation, "The Importance of Being Oscar," and an unnamed group or an individual artist from Mexico. Lady Bird accepted the chairmanship, but of the artists that Udall mentioned only Gielgud appeared for "An Evening with. . . ."[3]

With Mrs. Johnson present, the series moved for one event to a more suitable venue, the venerable National Theater. With a cast that included Diana Rigg, Julie Christie, Ian Richardson, Tony Church, and Alec McCowen, the Royal Shakespeare Company presented *The Comedy of Errors* in celebration of Shakespeare's four-hundredth anniversary. The invitation-only performance on April 13, 1964, was in advance of the public opening at the National on the following night.[4]

Stewart hit on an idea for the January 1965 inauguration of Lyndon B. Johnson. Stewart proposed to Bill Moyers of Johnson's staff that Carl Sandburg be invited to do "the Frost thing" at the ceremony. Udall believed it would be "wonderful for a poet to continue a tradition," and he suggested that Sandburg read his "The People, Yes." The idea died quietly. "Bill put it forward but nothing happened"; apparently the Johnson White House did not want to appear to be imitating Kennedy.[5]

Late in the Eisenhower administration, Congress had authorized a national performing arts facility for the capital, but private financing was required, and donations were slow in coming. Fund-raising accelerated after the assassination when it was announced that the projected facility would be named in honor of the slain president. It would be several years, however, before the John F. Kennedy Center for the Performing Arts was a reality. In February 1965, Roger Stevens, director of the nascent center, proposed to Stewart that the Metropolitan Opera National Company—"future stars of the opera"—could provide an excellent evening for the Artist Series. The new company, a joint promotion of the Met and the JFK Center, was to tour the nation to encourage more donations, Stevens said, and he believed that a publicized Washington evening would help the effort. On May 3, thirteen vocalists appeared on stage

at the Department of State auditorium, among them Ron Bottcher, Enrico di Giuseppe, Sylvia Friederich, Janet Pavel, and Mary Beth Peil.[6]

After a hiatus in the Artist Series, Hal Holbrook presented his "Mark Twain Tonight" on January 24, 1966. There was standing room only for his Twain monologue. Among the thirty or so who stood at the rear was the Italian ambassador. It was becoming increasingly apparent that the city needed something better for performances.[7]

One of the distinguished figures of the British stage, Sir John Gielgud, presented his "Ages of Man" on March 29, 1966. Three weeks later a musical group appeared, the new Princeton Chamber Orchestra (named for the town, not the university). Critics for the *Post* and the *Star* praised the program but disparaged the auditorium's acoustics.[8]

The next "Evening with . . ." featured poets Archibald MacLeish and Mark Van Doren, who read from their works and engaged in repartee for a pleased audience. It was the Cabinet Artist Series finale. After that "Evening," Udall recalls, events in Vietnam took "an ugly turn," and the series "faded out." What began with Frost on May 1, 1961, ended on the same stage on May 26, 1966, with Frost's friends MacLeish and Van Doren—a symbolic closing of the circle. In five years there had been fifteen "Evenings" of the Cabinet Artist Series. Shining Camelot had slipped away, dimmed first by the assassination of John F. Kennedy and then overshadowed by events in Southeast Asia. But what the Udalls had started with Frost in 1961 "had legs."[9]

Chapter 11 ———————————————————————

"The Nicest Thing Johnson Ever Did for Me"

AMERICA'S GROWING INTEREST in the arts did not cease. President Johnson signed legislation introduced by Representative Frank Thompson (D., N.J.) and Senator Claiborne Pell (D., R.I.) establishing the National Foundation for the Arts and Humanities as an umbrella for a National Endowment for the Arts and a National Endowment for the Humanities. Thompson was one of Udall's close friends in the House, their congressional offices had been side-by-side, and "he had been the initial sponsor of bills to establish the foundation way back in the 1950s." When the bill passed at last, Udall remained in the background; "I was not going to steal any of Thompson's thunder."[1]

Udall did go center stage in American culture in November 1964, when he traveled to New York City for a ceremony at the designation of Carnegie Hall as a National Historic Landmark. In gratitude, conductor Leopold Stokowski wrote, "All of us who value cultural standards are grateful to you. . . . If I can ever be of any assistance in the evolution of the Cultural Life of the United States I shall always be happy to cooperate with you in any way you might wish."[2]

Stewart's personal contributions to the culture included his own occasional poems. Sessions with his poetic muse could occur at any time. After Khrushchev was deposed, Udall recalled his visit with the Soviet leader in a poem published in *The Hudson Review*. He sent a clipping to Jack Valenti "as the official literary arbiter of the White House." Stewart said it was "my first published poem" (overlooking his verse in *Stars and Stripes* during World War II).

His first two stanzas:

> No longer master of the state,
> A Lear look on his famous face.
> He knows the passing of all power
> And rails within against his fate.
>
> Once at the Black Sea in his prime
> I heard him, eating with old friends,
> Tell peasant jokes and, toasting peace,
> Brandish the rockets of doom.[3]

The second of Stewart's cherished American poets, Carl Sandburg, died on July 22, 1967, and Stewart—solely on his own initiative, he emphasizes—determined to hold a memorial service at the Lincoln Memorial. "I could do that. I had the Park Service," which manages the memorial. President Johnson told Udall he wanted to attend, but because of the Vietnam War that the president seemingly could neither win nor abandon, Johnson was under siege by demonstrators at the White House and nearly everywhere he went except military bases. To avoid an interruption at the Sandburg service, the media was not informed of the president's plans.

Udall alerted George Hartzog, National Park Service director, of the president's intention and suggested that, because of the noise, an effort be made to reroute planes using National Airport, just down the Potomac from the Memorial. "Hell no!" Hartzog replied, "I want the president to see what they do to the Memorial."

When the program was about to begin, Johnson slipped onto the platform, joining Mrs. Sandburg and family, Chief Justice Warren and Mrs. Warren, newly appointed Justice Thurgood Marshall, Sandburg's Carolina writer friend Harry Golden, and the Udalls. Van Doren and MacLeish presented eulogies. After Charlie Byrd played two guitar pieces, soprano Jessye Norman began "There's a Man Goin' Roun' Takin' Names," during which several planes in close succession roared overhead. "As the planes got louder, she sang louder," Stewart recalls, "and Johnson waved them down." The president gave a cutoff signal to one of his entourage, and—promptly—National Airport remained out of business until the service ended. Without interference, Norman sang "He's Got The Whole World In His Hands." Her selections seemed uncannily appropriate.

The audience of several thousand made no disturbance when the president spoke. He was eloquent in his tribute to Sandburg, concluding:

What will live forever is his faith in the individual human beings whom we impersonally call "Americans." He knew that always in America, "the strong men keep coming on. . . ."

I will miss him; we will all miss him. There will not be one like him again.

Afterward, Johnson sent a note to Udall, thanking him for arranging the event. Stewart believes it was written by Valenti, but he cherishes it: "It was the nicest thing Johnson ever did for me."[4]

Udall's next book, *1976: Agenda for Tomorrow*, appeared in 1968 with an introduction by John Gardner, the secretary of health, education, and welfare, who took notice that Udall had moved

beyond the classic conservationist role. . . . His wide-ranging interests and curiosities, his broad personal and public experience of our national life, his inclination to deal with causes rather than symptoms drew him inevitably towards a diagnosis of our total problem. . . . [H]e plunges with vigor and understanding into unavoidable yet frequently ignored issues: politics, population, and the manner of life we want—and can achieve.[5]

Udall anticipated advances in urban design, population policy, and stewardship of air and water resources. Global warming was not a widely debated issue at the time, but Udall already was convinced of the danger. He warned, "Our technology is now pervasive enough to produce changes in world climate, even as inadvertent side effects, which could melt enough of the world's glaciers to cause the inundation of all coastal cities."

His book's theme was: "Great cities put people first. They use land lovingly to create . . . large and small boulevards, plazas, malls, vistas, squares, and waterscapes." In describing the "new conservation," Stewart declared, "Beauty and order should frame everyday life. The poet craves them, religion celebrates them, the democratic philosophy assumes them, and the latent naturalist and artist in every man thrives in their presence." His words appeared in 1968, months before the first Earth Day. He was advocating "an ecology of man." That was the key, the ecology of man.[6]

Opportunity to transfer some of his land-and-water-planning ideas from the printed page into action in a mixed urban-suburban-rural setting came Udall's way when President Johnson instructed Udall to "develop a program for the Potomac, 'The National River,' that would be a model of conservation and scenic beauty." The charge included the Potomac's Rock Creek tributary that flows through the District of Columbia. To aid in the multiagency study, Stewart wanted a skilled and sympathetic writer, and he successfully courted John Graves, author of *Goodbye to a River*, a prize-winning lyrical account of the Brazos. The Texas author remembers that Udall assured him that his "stint in Washington" probably would amount to only five or six weeks, but "it turned out to be three years." His assignment as writer-in-residence was an anomaly; he did not produce drafts for Stewart to shape into a distinctive Udall style, but he shared insights with Stewart on varied issues, and he wasn't consistently "in residence." Graves frequently adjourned to his rural Texas home to continue his research and writing there.

Stewart's respect for writers became evident to Graves, who recalls the creative freedom that Udall offered:

> I was allowed to go anywhere I wanted in the Potomac basin, sometimes in a car and on occasion in a canoe or a helicopter or a Maryland State Marine Police patrol boat. . . . All of this was heady stuff and there was a strong feeling that we were doing something that mattered. . . . [But] the multi-departmental structure of the program meant that none of my writing [for the study] could tread on the toes of the [Army Corps of] Engineers or the USDA, or even, within Interior, the BLM [Bureau of Land Management], and those did sometimes need treading on.

For the *Potomac Interim Report to the President*, Graves wrote over his byline "a riverman's essay," which he titled "A River and a Piece of Country," but the organizational structure of the watershed study limited his freedom to write of problems or solutions that might threaten the sensitive bureaucratic turf of some of the departments participating in the study.

Graves followed that essay with a much longer ramble in *The Creek and the City* about the national capital region's unique but damaged Rock Creek. Again Graves's name, not Udall's, appeared as the author. Graves was pleased with the lessened restrictions that the Rock Creek study permitted: "It was entirely an Interior [Department] thing. I conceived

the idea of using Rock Creek's problems as a sort of microcosm of the Potomac's woes, and sat down and wrote a longish essay to that effect without worrying about anybody's toes. Stewart liked it . . . and it was published in a pretty booklet entitled *The Creek and the City* about the watercourse." Graves's two down-home essays continue to read well, if you can find them. Published only in governmental reports, his work deserved better exposure. Much of Johnson's plan for the Potomac basin also disappeared, another Vietnam victim.[7]

While Graves was exploring the nooks and crannies of the Potomac watershed for Udall, the secretary ventured into the hazardous waters of population control. Stewart mailed Graves a forty-page early draft of an article that eventually appeared in the *Saturday Review*. The Texan replied with six single-spaced pages. Like Stegner's *Quiet Crisis* comments, Graves did not hold back. If anything, Graves's comments were even more direct. Planned parenthood was a hot potato, but Graves told Udall that he was weakening his argument with "hazinesses and indirectnesses"—thus revealing "a lingering doubt as to whether or not a man in your position can get away with strong direct statements on such sensitive matters." Graves laid it on the line:

> This is not a doubt that can be resolved for a cabinet officer by a lone rustic Texan with hardly any public responsibilities, but it does seem to me that if you can't get away with the strongest and most direct statements of your ideas here, you can't get away with weakened or indirect statements of them either, for the ideas are still there and you are going to be blamed or credited with them either way.[8]

When Udall's article appeared it showed that he had heeded Graves's advice. Udall wrote,

> The inhibitions of old cultures and outdated religious and economic doctrines have retarded the development of wise priorities for world wide population planning. . . . There has been too much nonsense written and spoken about the unlimited right of couples to have children, and too little sense about the primal responsibilities of child-rearing. . . . Parents can elect to have only those children they want—and wise men and women should want only the number they personally are psychologically and financially ready to rear.[9]

Birth control was far from Stewart's statutory duties, but he was practicing what he conceived as the duty of anyone in his position: to write and educate the public. He had announced in 1960 that he planned to do so; he was still doing it as he left office in 1969. And he continued doing it.

In the summer of 1961 Stewart and Lee (followed by a gaggle of photographers) hiked to Druid Arch in what became Canyonlands National Park in Utah. COURTESY STEWART UDALL.

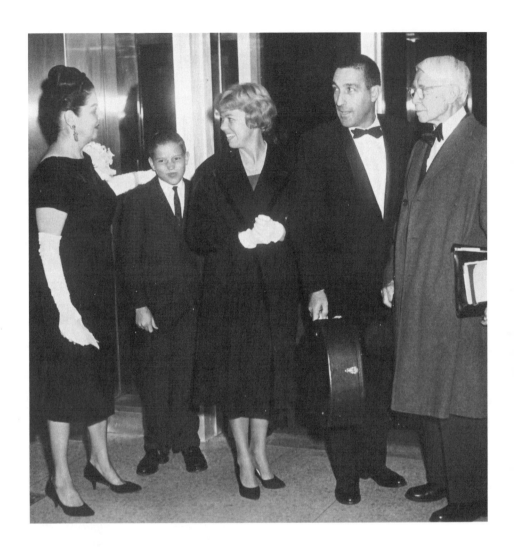

▲ Carl Sandburg arrived at the second of the Artist Series on October 26, 1961,
to be greeted by: (left to right) Maxine Lowry, receptionist/social secretary to
Secretary Udall; eleven-year-old Tommy Udall (much later a congressman from
New Mexico); and Lee and Stewart Udall. Photo by Abbie Rowe, National
Park Service. COURTESY STEWART UDALL.

▶ After an hour of "trifles and offerings," Carl Sandburg took up his
guitar and sang American ballads. Photo by Abbie Rowe.
COURTESY SPECIAL COLLECTIONS, UNIVERSITY OF ARIZONA LIBRARY.

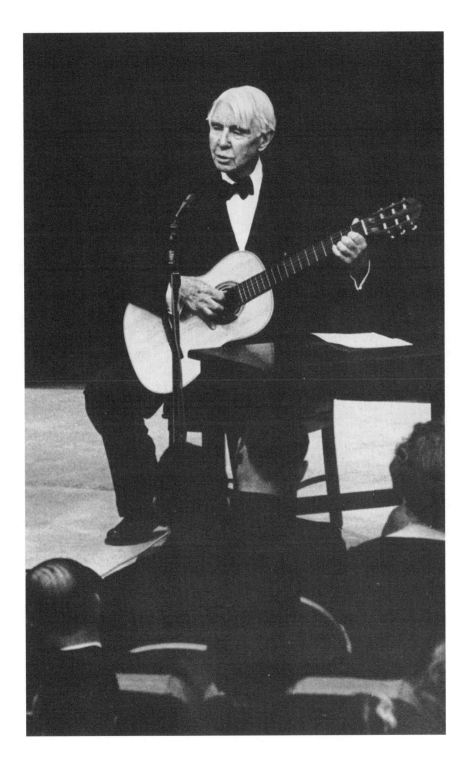

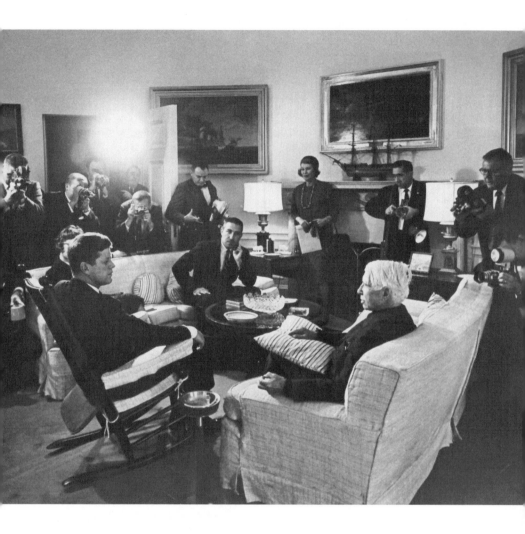

On the day after Sandburg's "Evening," he and Stewart Udall called on the
president, providing a media "photo op." Columnist Mary McGrory speculated that
Sandburg might become "a rival [of Frost] in the affections of the White House."
COURTESY STEWART UDALL.

Stewart Udall's staff wished him a "Happy Forty-second Birthday" on January 31, 1962, in the back parlor of the secretarial suite. AUTHOR'S COLLECTION.

"Poetry and power" gathered to celebrate Robert Frost's eighty-eighth birthday in the Hall of the Americas of the Pan-American Union on March 26, 1962. Washington Post writer Jean White observed, "It symbolically marked the height of recognition of the importance of arts in the American way of life, a special point of emphasis in the Kennedy administration." Photo by Abbie Rowe, National Park Service.
Courtesy Special Collections, University of Arizona Library.

Stewart Udall was invited to Soviet Premier Nikita Khrushchev's summer home, where the group talked amiably for several hours, swam in the Black Sea, and enjoyed a lunch with many toasts between courses. Photograph by Sovfoto. COURTESY STEWART UDALL.

One day after Stewart Udall's visit, Robert Frost was invited to meet Premier Khrushchev. When nearly there, the poet collapsed, exhausted.
So Khrushchev came to him, sitting by Frost's bedside. Photograph by Sovfoto.
Courtesy Special Collections, University of Arizona Library.

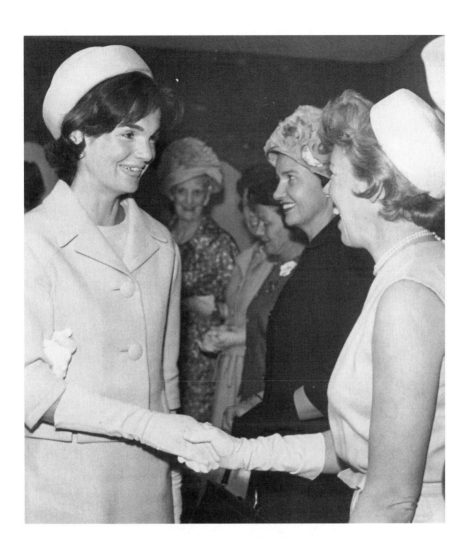

Pillbox hats were in vogue when Jacqueline Kennedy and Lee Udall met at a social affair. The identities of the other women are unknown. COURTESY STEWART UDALL.

▶ *Following two pages: To commemorate the 150th anniversary of the death of naturalist and author Henry David Thoreau, Stewart Udall arranged a simple ceremony at Dumbarton Oaks Park in Georgetown, D.C. Frost is speaking; looking on, among others, are Udall, Justice William O. Douglas, and Chief Justice Earl Warren. Photo by Abbie Rowe, National Park Service.* COURTESY SPECIAL COLLECTIONS, UNIVERSITY OF ARIZONA LIBRARY.

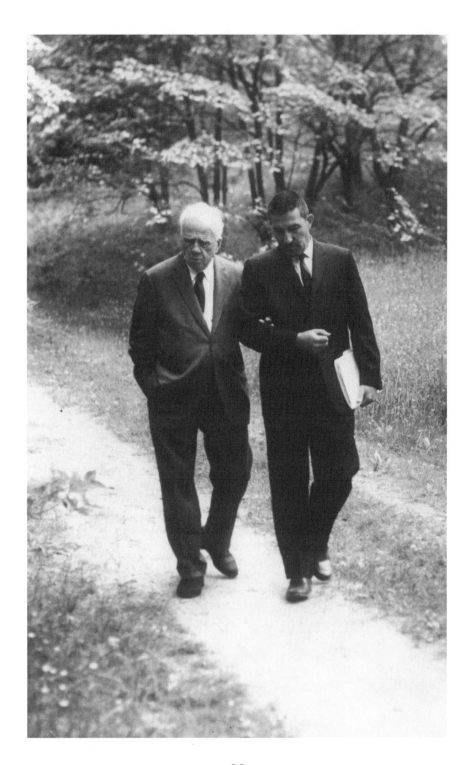

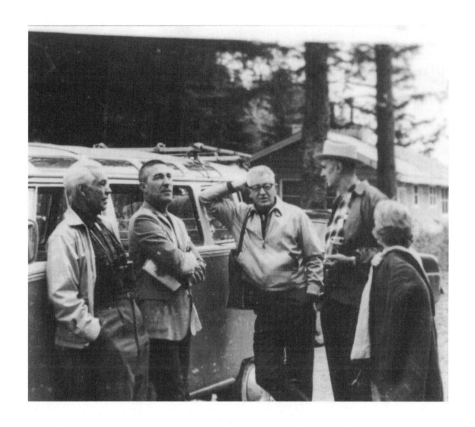

Somewhere in the field, left to right: *conservationist Sigurd Olson,
Stewart Udall, author Wallace Stegner, National Park Service Assistant
Director Edward Hummel, and Mary (Mrs. Wallace) Stegner.*
COURTESY OF MARY STEGNER AND JOANN SLOAN ROGERS.

◀ *As Robert Frost and Stewart Udall were walking out of the park after
the Thoreau affair, Frost told Udall, concerning Thoreau's sanctuary
at Walden Pond, "I've never been there. I couldn't bear it to go."
Photo by Abbie Rowe, National Park Service.*
COURTESY SPECIAL COLLECTIONS, UNIVERSITY OF ARIZONA LIBRARY.

A few years after Carl Sandburg's "Evening," he and the Udalls visited with Lady Bird Johnson in the Lincoln bedroom of the White House. Also present were the First Lady's daughters, Lynda Bird and Lucy Baines; Sandburg's wife, Lillian ("Paula"); and her brother, photographer Edward Steichen. White House photo by Robert L. Knudsen.
COURTESY SPECIAL COLLECTIONS, UNIVERSITY OF ARIZONA LIBRARY.

OFFICE OF
THE SECRETARY OF THE INTERIOR

"Baroom!"
(An Elephantine Verse)

A New musical drum
Was created, in Sum,
By the flatulent gas
from an elephant's ass.

— ₰ —

A bizarre news story inspired Stewart Udall to write "Baroom!"
COURTESY SPECIAL COLLECTIONS, UNIVERSITY OF ARIZONA LIBRARY.

Stewart Udall's "living-room diplomacy" saved Frank Lloyd Wright's
"Usonian" House. At the reopening, Udall was joined by Gordon Gray,
president of the National Trust for Historic Preservation.

A Poet Sublime and Comic

STEWART OCCASIONALLY EXPRESSED HIMSELF in poetry, and in one instance he was inspired by his concern for the human environment. He was in San Diego, walking on the beach one early morning at the Hotel del Coronado. An airplane overhead disturbed the seaside calm.

Back in his room at the hotel, Stewart seized on a piece of cardboard, probably from a shirt, to record his unhappiness with the disturbance:

Once By the Pacific

At sunrise near a city on a beach
I heard the wash of surf
The calls of birds
The chiming of church bells
A fog horn's far-off song
A dog's cry and a boy's.

Tender noise like this
Has salved the waking mind
Since Homer; but sullen morning came
And engines ripped the urban air
Annulling all the subtle sounds.
Must all the soft chords go,
Torn by a savage celerity,
To caress us only at dawn and dusk?
Or must we curse the sonic time
And brace our ears against the din?

The title duplicated that of a Frost poem, although the substance was quite different. The *Saturday Review* published "Once By the Pacific" with a note by editor John Ciardi: "Poets, as Shelley claimed, are the unacknowledged legislators of the world. . . . Let legislators be acknowledged poets and we shall all, I must believe, be better governed. We welcome Secretary Udall to the roster of *SR* poets."[1]

Not every poem of his was as serious. Stewart's versifying took a humorous turn when he read a news story out of Vietnam that the army planned to drop four bull elephants by parachute into the jungle where they would be strapped onto a raft and immobilized with an experimental drug M-99. An army veterinarian explained (?!): "Researchers have found that under the influence of M-99 elephants expel flatulent gasses." The news item offered no further information, except that the code word for the peculiar experiment was "Baroom." That set Stewart's poetic juices flowing, and he wrote on secretarial note paper:

BAROOM

(An Elephantine Verse)
A NEW MUSICAL DRUM
WAS CREATED, IN SUM,
BY THE FLATULENT GAS
FROM AN ELEPHANT'S ASS.

S.[2]

"A Preservation Classic"

IN MANY WAYS STEWART continued to demonstrate the validity of the journalist's description of him as "Secretary of Things in General," involving himself with statuary, architecture, theater, and design. In his congressional years he had spoken out about the proliferation of statues in Washington. Now that he was the man in charge, he urged the Park Service to consider thinning the marble and bronze crop. He announced that a larger-than-life bronze of William Jennings Bryan by Gutzon Borglum would be sent on "indefinite loan" to Bryan's birthplace, Salem, Illinois. Bryan, thrice the Democratic nominee for president and Woodrow Wilson's secretary of state, was not an insignificant figure, but hardly one of transcendental importance. "Spokesmen for the nation's tradition-minded sculptors promptly claimed that Udall was exiling the statue because of his own hostility to the art form," a magazine writer reported. "They dug up a speech that Congressman Udall made two years earlier in which he complained that two hundred statues and memorials "dot the Washington landscape . . . as patriotic societies and zealous friends are constantly hatching new plans."

Hoping to slow the proliferation, Congressman Udall had proposed that a politician be at least fifty years dead before being memorialized.[1]

After the Bryan statue became news, Secretary Udall called a press conference at which he contended that the District of Columbia had "only a limited number of really good sites." He wrote an article for the New York Times Magazine, "Monumental Look at Washington D.C.," declaring that a monument "should be more than a decorative adjunct. It must have the power to move

deeply and to make history, truth and dignity at once visible in bronze or stone." Especially, he wrote, statuary in the national capital should "above all, deepen our understanding of the nation's highest aspirations and best moments." (Bryan's aspirations were persistently high and his best moments included serving as prosecutor in the Scopes "monkey trial.") The Park Service had counted, Udall reported, a "confused and confusing assortment of more than 500 statues, busts, urns, spheres, shafts, temples and carillons, some of which commemorate men and events of fleeting prominence or historical importance." He countered the criticism by some sculptors by quoting, favorably, sculptor Saint-Gaudens's remark that equestrian statues of Civil War generals should all be put in one place "so that a high board fence could be built around the lot of them." Except for the Bryan statue loan (it remains in Salem), Stewart lost that battle.[2]

Udall was more successful with another local issue, *saving* what was a monument in a sense but was, in Udall's words, "something better" than chiseled stone. One of Frank Lloyd Wright's "Usonian" houses in nearby suburban Virginia was in danger of destruction. Modest, not in the impressive mode of his Fallingwater or Robie House, it was Wright's concept of an affordable middle-class home. Only thirty-five Usonians were built, and the sole example in the national capital area was the 1939 residence known as the Pope-Leighey House. In 1961, when the Virginia highway department staked the route for Interstate 66 through Arlington and Fairfax counties, the house was in the planned right-of-way, scheduled to be condemned. Highway engineers insisted that their plans were too far along to be changed. What happened next became, in the words of one editor, "a preservation classic."[3]

Mrs. Robert Leighey, who had lived in the house for eighteen years, sought help from Udall. He addressed the Fairfax County Federation of Citizens' Associations, urging his neighbors to "make a concerted effort for state and national preservation . . . of the county's scenic and historic landmarks." With the highway department adamant, however, a more timely solution was needed. So, on a rainy day in March 1964, representatives of all parties met at the house where Stewart employed "living-room diplomacy" and worked out a solution that all accepted. There would be no condemnation. Mrs. Leighey would donate the house if the National Trust for Historic Preservation would pay to move it several miles to Woodlawn Plantation, a Trust property that

protects a grand 1805 manor house. The estate included a secluded glen similar to the site that Wright's small gem had occupied for twenty-five years; the Usonian house would be rebuilt there. As Udall said, "There is a sublime irony in the circumstance that one of Frank Lloyd Wright's most modest buildings should repose on one of America's most historic, most staid, and most handsome estates." He was pleased that Mrs. Leighey's gift "enabled the right hand of the government to rescue this Wright cameo from its left hand," but his last-minute saving of the Usonian house was a one-time historic preservation solution, good for only one site. As the new interstate highway program gained momentum, more such confrontations could be foreseen, as could other conflicts involving historic properties and a variety of federally aided construction projects.[4]

The "right hand–left hand" problem dramatized a need for protection of the nation's heritage. Publicity about the Pope-Leighey House problem set the wheels in motion. Congress approved the National Historic Preservation Act—establishing the National Register of Historic Sites. The act requires, for a project involving federal funding or approval, negotiations to avoid or minimize adverse effects on properties listed on the National Register. Udall's living-room diplomacy opened the way for protection of many historic properties across the nation.

At the Pope-Leighey House, Udall also observed that governments in America had bypassed Wright in awarding architecture contracts. He noted that the "most renowned American designer of this century never completed a structure built with public funds in his seventy years as an architect."

In an article titled, "Can Federal Architecture Be Creative?" published in the *Arizona Architect* magazine, Udall praised Richard Neutra and Robert E. Alexander for their design contributions to the Painted Desert National Park community. He also wrote articles for the American Institute of Architects' *AIA Journal*, and in Phoenix's *Arizona Republic* he advocated the construction of a new state capitol to replace the small, squat building that had been constructed during Arizona's territorial days. "Why Not a Grand State Capitol for the Grand Canyon State?" he asked. That hasn't happened yet.[5]

Udall welcomed Lady Bird Johnson's well-publicized efforts for a more beautiful America—a successful and continuing effort that fit into his vision. In and around Washington especially, the results of her program continue to brighten the city. The national capital area also contains several other cultural

legacies of the Kennedy-Johnson administrations in which Udall initiatives were a significant element. Among the prominent features are the performance facilities initiated in the mid- and late-1960s: the John F. Kennedy Center for the Performing Arts in Potomac Park overlooking the river, the Wolf Trap Farm Park for the Performing Arts in suburban Virginia, and the restored Ford's Theatre in downtown Washington.

Only a month before his death, President Kennedy opened a major fund drive for the National Cultural Center. After his assassination in November 1963, donations flowed in and the desire to honor the martyred President led to a renaming of the center. In December 1964, President Johnson presided at the ceremonial groundbreaking for the Kennedy Center. The building includes several performance venues and rehearsal rooms; a particular highlight for the nation is the annual presentation there of the Kennedy Center Awards, attended by the president and the First Lady, and telecast nationally. Stewart is pleased that a wall in the building bears a quotation from Kennedy's Amherst speech honoring Frost.[6]

The growing emphasis on the arts in the 1960s also made evident to Catharine Filene Shouse (Mrs. Jouett Shouse) Washington's shortage of performance venues, and she had the interest and the means to help correct the deficiency. Mrs. Shouse was of Boston's philanthropic Filene mercantile family, major supporters of the Boston Symphony, and she was familiar with theaters throughout the world. In the 1930s she had purchased several hundred acres of woods and meadows near Vienna, Fairfax County, Virginia, as a rural retreat. She called it Wolf Trap Farm, named for a small stream on the property. By 1964, suburban spread threatened the quiet life of that countryside. She approached Lady Bird Johnson with a question, "Would the Park Service be interested in acquiring Wolf Trap?" The proposal was referred to a surprised, but immediately enthusiastic, Secretary Udall. There was a catch: Mrs. Shouse would donate her farm, valued at more than $4 million, *provided* that it be used specifically for the performing arts. For Stewart, this was an astonishing windfall, and he went to Congress for authorizing legislation. Congress agreed, establishing America's first national park of its kind, Wolf Trap Farm Park for the Performing Arts.

On May 22, 1968, the First Lady presided at the groundbreaking for the center. Accompanying Mrs. Johnson was Secretary Udall, who presented Mrs. Shouse with the ceremonial shovel and remarked, "Kay, I don't think it's a

fair exchange. You gave us a farm and I give you a shovel." Her involvement continued, as more than a formality. She had a vision of what was possible and she consulted with the architects as they designed a remarkable facility capable of seating four thousand concertgoers under the roof, plus another three thousand beyond on a sloping lawn.[7]

"That's What Lincoln Would Want"

STEWART BECAME INTIMATELY INVOLVED with the rebirth of Ford's Theatre, site of Lincoln's assassination. It was closed after the president's death and served for a time as a warehouse. The National Park Service acquired it and developed a small museum in a part of the building, preserving it along with the "House Where Lincoln Died" across Tenth Street in downtown Washington. Stewart learned that the Park Service was contemplating using the theatre and the house as the setting for an outdoor "Sound-and-Light" show. The French interpretive concept "Son et Lumière" already had attracted Udall's attention, but he was open to alternatives. In 1965, a persuasive Frankie Hewitt, then the wife of CBS producer Don Hewitt, pressed Stewart to return the theatre to its original purpose, to light up the stage that had been dark for more than a century. "That's what Lincoln would want," she declared.[1]

Udall was convinced. "Frankie had extraordinary political skills," although she was not a partisan of any party. Support for the theatre was not a partisan issue; Republican senator Milton R. Young of North Dakota teamed with Udall in winning appropriations for the theatre's restoration. Mrs. Hewitt knew of a theatrical company that would stage performances at Ford's once the interior was restored, and Stewart hired her as a consultant. She founded the nonprofit Ford's Theatre Society to raise money for live productions. Success! In the words of the *Washington Post* she was "a prodigious fund-raiser."

Immediately prior to the reopening, the Associated Press mused: "No voices, no music, no light has shone on this stage since April 14, 1865, when President Lincoln was shot." That changed on January 30, 1968, when a thousand invited guests attended a reopening gala,

broadcast nationally by CBS Television. The guest list was twice the theatre's seating capacity (with the flag-draped Lincoln box always to remain empty), so two performances were presented that night, with receptions following in a nearby office building. Once again, a crisis in Southeast Asia interfered with presidential participation in a cultural event. A few hours earlier, North Vietnam had set off the Tet offensive, striking dozens of targets and attacking the U.S. embassy in Saigon. President Johnson remained deep in conference at the White House. Vice President Humphrey did join the throng of guests, and Illinois Republican senator Everett Dirksen was the principal speaker for the ceremony. Stars of Broadway and Hollywood were present in numbers: Helen Hayes, Frederic March, Henry Fonda, Harry Belafonte, Andy Williams, Odetta, Richard Crenna, Robert Ryan, Nina Foch, and more. Among the musical entertainers were soprano Patricia Brooks and the Marine Band. It was a grand night for the nation, and for Stewart Udall. Within a few weeks the theatre reopened for scheduled performances, with the first performance based on Stephen Vincent Benet's narrative poem, *John Brown's Body*. Since February 1968 scheduled performances have kept the stage lit. Today Stewart considers the restoration of Ford's Theatre for live productions one of his major arts achievements.[2]

Administrations came and went, and Frankie Hewitt continued her galas; she produced more than 150 plays at Ford's until her death in February 2003. At her memorial service, Interior Secretary Gale Norton ignored Stewart's actions, giving credit instead to Wallace Hickel, Udall's Republican successor: "Frankie Hewitt had obstacles to overcome. Let's just say that back in 1969 [*sic*] live theatre and the National Park Service were not necessarily a comfortable fit. That is about when Secretary of the Interior Wally Hickel first got to know Frankie Hewitt. It didn't take Secretary Hickel long to determine that bringing actors back to the stage at Ford's Theatre was just a fine idea."[3]

Political partisanship is a given in Washington; sometimes it is in good spirit among adversaries who also can be friends. An example occurred when Udall modernized his department's official seal in 1968. He selected a graphic design firm to produce a new emblem. The seal was not sacrosanct; in earlier decades an eagle and a buffalo had alternated on the seal. In the 1960s the version of the buffalo design in use dated only from 1929. Nonetheless, traditionalists opposed the change when Udall unveiled the new design. He explained his reason for modernizing the seal: "Our old bison symbol seemed appropriate

enough as long as Interior was primarily a Department of the West, but our resource responsibilities now span the whole country as never before." The new seal, a departmental press release explained, expressed Interior's environmental mission with symbols of "the dynamic forces that have shaped the earth—the sun, mountains, water—framed by a stylized pair of hands." Critic Wolf Von Eckardt of the *Washington Post* praised the new seal, calling it "a masterpiece . . . a breath of fresh air" sweeping through "the stifling mediocrity of government design. . . . It says without words that the hands of government protect our natural environment." It seemed inevitable, however, that many people would link the design with an insurance company's ads that proclaimed, "You're in good hands with Allstate." One who did so was Barry Goldwater.[4]

Arizona's Republican senator addressed the annual Western History Association conference, coincidentally in Tucson that year. He observed, "Little imagery is required to see that the Department of the Interior seal is boasting: 'You're in good hands with Secretary Udall.'" Arizonans, Goldwater noted, "remember Stew fondly as a member of a respected Mormon family, a rugged athlete . . . popular Congressman . . . a politician . . . who won for himself a niche in the president's cabinet." He praised Udall as "a great conservationist and one of the finest Secretaries of the Interior the nation has had." But, he went on, Interior controls "to an alarming degree" almost 45 percent of Arizona's land surface, and "in Arizona we recognize that—like it or not—we're in Stew's hands."

Goldwater's remarks made news. A few days later, he sent Udall a copy of his text, telling "Dear Stew" that the Associated Press had distorted his comment about the seal and "the spirit in which it was said." Their friendship continued.[5]

After Walter Hickel became secretary he restored the bison seal. Von Eckardt called that a "hick" action generated by "mossbacks." Recently, Stewart said, "I did it too late. I should have done it earlier in my term," thus allowing more time for it to become accepted.[6]

"I Was a Good Prodder"

LEE WAS IN HER TEENS when Interior Secretary Harold Ickes planned his department's new headquarters building in Washington and insisted that the structure include an art gallery. He got three rooms with twenty-eight hundred square feet of space, windowless but with skylights since it was on the top (seventh) floor. A gallery such as Ickes created was not a common feature of government office buildings, and it received a well-publicized debut when it opened in 1937. FDR's New Deal included an emphasis on American art, with many post-office murals, and in Ickes's building several murals were painted by American regionalists of the era, including Millard Sheets, Maynard Dixon, and John Steuart Curry. First Lady Eleanor Roosevelt presided at the art gallery opening, with Ickes at her side. The first exhibit featured oils by university students, the show being sponsored by the U.S. Office of Education, then an Interior Department bureau. Five years later, during World War II, the gallery was converted to offices and storage, and so it remained into the Udall era when the *Washington Post* called it "Interior's lost gallery."[1]

In the Stewart Udall Collection at the University of Arizona are two and one-half pages typewritten by Lee. They are unquestionably hers, though not signed or dated—and apparently never published. She wrote,

> Stewart's appointment [as Interior secretary] was a happy coincidence for me. Having grown up in the Southwest, I have a deep interest in the art and native cultural heritage of the American Indians. Being a member of a family who loves the out-of-doors, my other love is the land. Embracing both the Bureau of Indian Affairs and the National Park Service, . . .

Interior held the official key to my natural interests. It was, I thought, almost too good to be true.[2]

Shortly before Stewart became secretary, Interior's Bureau of Indian Affairs created the Institute of American Indian Arts (IAIA) in Santa Fe, a specialized high school and post–high school center for the arts, open to students from all the American Indian nations. A few months after Stewart was sworn in, Lee visited the institute, explaining that she and Stewart had "always been deeply interested in the Indian people and their art." The visions of Lloyd Kiva New, Jim McGrath, and many other leaders in Indian education inspired Lee. The IAIA founding concept was a "totality of learning," using the arts as the vehicle for broad-based studies; the school encouraged self-identity and individual expression. At nearly the same time, Lee learned of Interior's abandoned art gallery from Bill Walton, chairman of the Fine Arts Commission of the District of Columbia, and a close friend of President and Mrs. Kennedy. An idea clicked with Lee: a joyous, fruitful conjunction of Indian arts, an empty gallery that called for rescuing, and a woman in a position of influence. It was fate, the new Indian Arts Institute won a champion, and Lee Udall discovered a worthy cause. She inspected the gallery space and recognized its potential for display of works by students at the Santa Fe school, and for other arts promotions. Stewart began to feel some wifely prodding to have the gallery restored to its original purpose. Lee told the *Post*, "I was a good prodder."[3]

Lee set out to make the world more appreciative of American Indian culture, first enlisting the IAIA staff to help in planning the gallery restoration. As a link with the gallery's originator, Jane Ickes, the late secretary's second wife, joined the Udalls for the reopening in May 1964. Wives of Interior employees served as volunteer docents. A Santa Fe newspaper praised the show as "the most comprehensive collection of twentieth century American Indian paintings, sculpture and handicrafts ever assembled." The *Washington Post* called the first show "a stunning exhibition of Indian art."

For the opening show, each room featured a different facet of Indian art. One exhibited contemporary paintings from the Denman collection of New York City's Museum of Modern Art. An eclectic exhibit of works by IAIA students filled a second room: poetry, paintings, textiles, ceramics, metal and marble sculptures, and wood carvings. One of the docents, Roberta (Mrs. James) Officer, remembers how much Lee enjoyed children and wanted the

galleries to be "as great to children as adults." Because of that, the third room exhibited the work of children, from first-graders up, representing about eighty Indian Bureau schools. The young artists' creations were available for purchase. A six-year-old Alaska Native boy added this message to his crayon drawing of a fishing village: "Dear Mr. and Mrs. Udall: I did not make this painting to sell. I make it for fun. Please give it to anybody who likes it. Your friend, Mike Matchian."[4]

Lee, too, was for fun. Described by a friend as "warm, funny, brilliant, effective, and kind . . . the personification of class," she had settled comfortably into her role as the wife of a cabinet officer. She *was* classy, but at times her playful side took over. At an informal outdoor party at Robert Kennedy's home, Arthur Schlesinger, Jr., showed up in bow tie and pin-striped suit. Soon, he found himself treading water in the swimming pool. Party-goers thought Ethel Kennedy had pushed him, but later Lee told *Time* magazine that she elbowed the political scholar into the pool because he simply looked "too Arthurish" for the occasion. Another evidence of Lee's fun-loving personality is recalled by Roberta Officer. At a party for adults and children that the Udalls hosted, a tug-of-war was organized with herself and Lee on opposite teams, each with several youngsters. It was a no-holds-barred affair, during which Lee managed to pull Officer's hair. "That's what happens at a Kennedy party," Lee told her.[5]

After opening the gallery, Lee incorporated the Center for the Arts of Indian America, hoping to increase financial help for arts education of young Indians. Her progress amazed Stewart, "Here she was the mother of six children . . . and then she started this project and it just took off." Officer, who knew Lee in Tucson and in Washington, describes her: "bright . . . sparkly . . . sweet but strong-minded . . . very much a doer . . . very good at meeting people." At Interior's gallery, exhibits were not limited to Indian art; one show displayed the paintings of youthful wildlife artist Ray Harm. Another exhibited Ansel Adams photographs. To publicize the show, Lee posed with Adams before a large print of his memorable *Moonrise, Hernandez New Mexico, 1941.* The wildlife paintings of Walter A. Weber followed, as did an exhibition of works by Interior employees, but advancing Indian arts remained the prime purpose.

Maria Martinez of San Ildefonso Pueblo, New Mexico, came to the gallery for an exhibit of her family's artistry. Maria's black-on-black pottery, famous

for decades, did not *need* Washington exposure, but her presence enhanced the gallery's stature. Alongside Maria's creations were the pottery art of her son, Popovi Da, and the paintings of her grandson, Tony Da. An exhibit catalog produced by IAIA students and faculty included a tribute to "The House of Martinez" by Lloyd Kiva New, the art director and later president of the school. A publication titled *Powhage* (the name for San Ildefonso in the pueblo's Tanoan language) documented the family's work, with photographs by Laura Gilpin of Santa Fe and poetry by Otellie Laloma, Hopi; Larry Bird, Santo Domingo-Laguna; Libby Alexander, Spokane; and Grey Cohoe, Navajo.[6]

Lee's Center for the Arts of Indian America sponsored "Three from Santa Fe," a show of the works of three IAIA faculty members: Laloma, McGrath, and Fritz Scholder. Vincent Price, well known as an actor of stage, radio, motion pictures, and television, less well known as a connoisseur of primitive and modern art, wrote the introduction to the catalog.

Price, a Yale graduate in art history, appreciated Indian art. He provided prizes for IAIA students, joined the board of directors of the Center for Arts of Indian America, and also served many years on Interior's Indian Arts and Crafts Board. From 1966 to 1970 the *Chicago Tribune* published his column, "Vincent Price on Art." In one of Price's articles, headed "Our Indian Art Is Ignored Unjustly," he wrote:

> Fortunately, the secretary of the interior, Stewart Udall, and his wife, Lee, are people at the top who are interested in all aspects of Indian life, including art. The former has done much to encourage and protect Indian art, and the latter can add a new dimension to public understanding of these creative people.[7]

With Stewart's help, Lee found money for Indian art exhibits overseas in Edinburgh, London, Berlin, and Ankara. Fascinated crowds watched Navajo Fred Stevens produce sand paintings while Mrs. Bertha Stevens demonstrated weaving on a traditional vertical loom.[8]

The Udalls brought outstanding students—Kevin Red Star, Earl Eder, and Alfred Cloh among them—to Washington to further their education. The young men bedded at Crest Lane, and Stewart took them on a Sunday drive to Potomac Park where the budding artists spotted interesting-looking driftwood along the river bank. As they were loading the wood in the Udall car, a National Park Service ranger appeared. Oops! The wood returned to

the river bank. Lee arranged for the students to travel to New York with McGrath to visit museums; they surprised McGrath by their interest in Central Park's horses and carriages. Presumably the visitors were amazed at seeing horse-drawn vehicles amidst the auto congestion.[9]

Lee found another way to spread appreciation of Indian cultures: bring visitors to Santa Fe. With an eye to publicity for the IAIA—and future funding support—Lee persuaded prominent persons to detour to Santa Fe to see the students at the institute. Among such visitors were violinist Menuhin, arts patron Peggy Guggenheim, and dancer José Limon of the Juilliard faculty. Lee and Lady Bird Johnson flew to Santa Fe to visit the institute, and the First Lady delighted students with her interest in their varied forms of art. Not only were Lee's guests introduced to the students and their work, but they also were exposed to the many examples of Indian culture so readily apparent in the unique little city and surrounding region. The visits also let young Indian students observe representatives of a cosmopolitan culture alien to many of them.[10]

In Washington, Lee's promotions extended beyond the gallery, encompassing dance and other performing arts. With Udall sponsorship, the First American Indian Performing Arts Festival presented eighty-seven male and female students from twenty-four Indian nations who interpreted traditional themes through drama, dance, and musical compositions. Carter Barron Amphitheater in Rock Creek Park served as the venue. Simultaneously, an exhibit of art in various media and poetry was showing at Interior's gallery. One year later another IAIA production filled the Carter Barron stage. Composer Louis Ballard created *Sipapu*, based on myths, chants, and dance—traditional and modern; it was performed by seventy-five youths from thirty-one Indian nations. Despite chilly, rainy weather during the five-day run, a reviewer called the audience response "anything but cold."[11]

The media took note when Lee brought young Apaches to perform traditional dances before President and Mrs. Johnson in the East Room of the White House. For that venue, weather was not a problem, but another hazard developed. In some Apache ceremonies, participants wear elaborate wooden headdresses, hence the name "Crown Dancers." It was discovered—ahead of time, fortunately—that the towering headdresses would strike the lowest portions of the East Room crystal chandeliers. The White House staff removed the endangered prisms.[12]

To the extent she could, Lee shunned personal publicity, but she welcomed publicity for the Indian arts. She did have some reservations, however. In reporting the arts events, the Washington press—*Post, Evening Star*, and *Daily News*—seemed unable to avoid stereotypes of Indians. Headlines referred to a "Pow Wow," the "Braves' New World," "Interior's Tepee," and a "Red Blooded" show. Lee tried to squelch the trend, to no avail. Under a headline, "No Hokum about Heap Big Indian Show Here, Mrs. Udall Pleads," an *Evening Star* story began: "Seventy-five savages and a yellow-haired friend of the Great White Father held a powwow with the press at Carter Barron Amphitheater yesterday."[13]

Lee's efforts led to a different dance outlet for Indian youth. Louis Ballard brought her an idea and she took it to Rebekah Harkness, the wealthy sponsor of a ballet company, persuading her to finance a ballet reflecting American Indian culture with a score composed by Ballard and choreography by Donald Saddler. Stewart, increasingly proud of his wife's projects, commented, "It was an example of Lee's initiative in enabling young Indians to get ahead." The Harkness Ballet Company presented *Kochare*, named for the Hopi sacred clown, in which Indian dancers interpreted the Hopi creation myth and depicted scenes from Indian life. One of Ballard's compositions, a signature piece of his, was "Why the Duck Has a Short Tail," decidedly not a title to be found in the conventional ballet repertoire. Harkness arranged for the first performance to be at Barcelona. Lee flew to Spain for the premiere; Stewart says "we were poor, maybe Ms. Harkness paid for that."[14]

On its return to America, the company performed in Washington at George Washington University's Lisner Auditorium; Lady Bird Johnson and Muriel Humphrey, the vice president's wife, joined Lee as patrons. The ballet company traveled on to Houston, Oklahoma City, Denver, and elsewhere to benefit Lee's Center for American Indian Arts. Black-tie opening night performances set the pattern. The Udalls attended the Houston evening and saved the night's program that listed patrons for the performance. The names included many of Texas's elite: McCollum, Bentsen, Hobby, Jaworski, Parten, Wortham, and so on.[15]

Traditionally, cabinet wives were looked to for leadership in public duties. Lee took on the renovation of the library collection at Blair House, the official guest quarters near the White House for heads of state and other distinguished visitors. The library needed organizing and updating; Lee contacted twenty-

seven American publishing houses requesting appropriate books. Other duties not necessarily involving the arts drew her attention also: entertaining Queen Homaira of Afghanistan on the presidential yacht *Sequoia*, leading children's hikes along the C & O Canal towpath, joining with *Washington Post* publisher Katherine Graham in ribbon-cutting at an arts fair, serving as patron for Carter Barron performances of Mozart's *The Magic Flute* with the National Symphony and Washington Civic Opera, and opening a District of Columbia flower show. But those years were coming to an end.[16]

Chapter 16 ———————————————

"Her Extraordinary Friendliness"

LYNDON JOHNSON DECLINED to run for another term in 1968, and Republican Richard Nixon won the presidency. When Udall's appointment as secretary ended in January 1969, he was in debt. The Udalls decided to remain in the Washington area, and Stewart—like many another ex-government official—formed a consulting firm, Overview. He hoped to attract international clients interested in protecting the environment. Harvard awarded him an honorary degree but, probably more helpful at the time, Yale appointed him for a year as an adjunct professor of environmental humanism. ("I don't know what it means," he said.) A newspaper writer described Udall the professor as "one-third government expert, one-third philosopher, and one-third western posse."[1]

The posse rode off in all directions when Stewart began writing in earnest, to help earn a living. Articles by the former secretary eventually began appearing in such diverse publications as *Atlantic Monthly*, *TV Week*, *New Mexico Alumnus*, *Sunday Washington Star*, *American University Law Review*, *National Wildlife*, (United Airlines) *Mainliner*, *Annals of Internal Medicine*, and more.[2]

Even as his work appeared in a variety of publications, Udall continued to seek reassurance and guidance from his writer friends. One such advisor was poet William Meredith. Their friendship began when he accompanied Frost to Tucson in 1960. Stewart turned to him for criticism of articles he was writing in the 1970s. One draft, "Robert Frost, Kennedy, and Khrushchev: A Memoir of Poetry and Power," drew these comments from Meredith: "I have again attacked your, to me, excessive use of dashes for emphasis. . . . If you look at the pencil marks page by page it will be clear what I mean at each point. . . . In the scene at Gagra [with Khrushchev],

I think it is important to be more visual and dramatic. . . . It can be done just by a sentence or two, I think. [My suggestions] are all considered judgements [*sic*] about a piece of writing which . . . strikes me as lucid and finished, needing little or nothing unless such changes as I or others offer appeal to you."[3]

Without the prestige of a cabinet office, the Udalls' involvement with the arts in Washington lessened, becoming one of continuing personal friendships with artists and writers, not the sponsorship of cultural events. However, momentum generated by the attention that Stewart directed to America's natural resources alerted the public to threats to the environment and to the need for its protection.

A notable result was the first Earth Day in 1970. Its celebration inspired Stewart to launch a twice-weekly newspaper column, "Udall on the Environment," first distributed by New York City's *Newsday* and soon acquired by the Los Angeles Times Syndicate. Stewart found that "I didn't have enough time." For help as coauthor he recruited Jeff Stansbury, a writer-lecturer on ecology, population, and the environment. "Jeff was a kind of bomb-thrower, but very well informed."[4]

After two years as a columnist, Udall quit the column to assist in George McGovern's unsuccessful 1972 campaign for the presidency. During his brief fling at journalism Stewart also wrote the text for the beautifully illustrated *America's National Treasures: National Natural Monuments and Seashores*.

He went on to address serious public issues in *The Energy Balloon*. Coauthored with Charles Conconi and David Osterhout, the book, described by its authors as outspoken and argumentative, discussed "technology and civilization" and analyzed America's wasteful energy habits. The team of authors discussed radioactive storage and waste disposal, "a thousand year problem," and noted the potential for nuclear "blackmail" by terrorist groups and nations. The authors called for increased attention to wind and solar energy. Foreseeing an end to "the era of cheap energy," Udall and his colleagues advocated major changes in America's culture, a rethinking of industrial systems, serious energy conservation measures, and an end to urban sprawl. It was "a consciously provocative book." After its publication, Stewart's output of books ceased for thirteen years.[5]

Party politics resurfaced in 1976 when Stewart became a prime mover in brother Mo's campaign for the Democratic presidential nomination. After Mo's loss to Jimmy Carter, Stewart became increasingly committed to litiga-

tion resulting from the atomic energy push of a generation earlier. He took leadership in damage suits on behalf of Navajo miners and their survivors who were not told of the danger of radiation exposure during the miners' years in uranium mines and were suffering the health consequences. He also began representing atomic test-site workers and those he calls "downwinders" in Nevada and Utah who had been exposed to radiation from atmospheric testing of atomic bombs. His actions led to "fifteen years of labor as a lawyer groping for truths in the dark woods of the Cold War."[6]

With Stewart out of office, Lee found that the family's opportunities for major cultural encounters dwindled. She continued her advocacy of American Indian arts and expanded her interests across the map of the United States, encompassing a variety of American folk cultures. In so doing, she became acquainted with Joe Wilson, the director and moving force behind the National Council for the Traditional Arts. The homespun folklorist welcomed Lee as a volunteer at the folklife organization's new national office just off Dupont Circle in Washington. She found a movement that welcomed her organizing skills and energy. The four-decades-old organization had moved its annual National Folklife Festival to newly opened Wolf Trap Farm, and there was work to be done. Wilson discovered that Lee was "an inquiring person" with organizing ability, "impeccable taste," and writing skills. Further, in her consultations with folk-festival participants, "her extraordinary friendliness made her good with working people." That confirmed an observation by her long-time friend Roberta Officer, who recalls, "She always seemed to have people around."[7]

After her initial uncertainties in Washington, Lee had became fully at ease in the highest of the capital's social circles, but Wilson observed that "she kept to a working folks ethic—get a lot of work done early in the day, and invite friends for dinner and laugh with them because life is funny." He discovered, "She was great at the blues!" Lee's volunteering led to employment and, ultimately, to the position of associate director of the council. As such, she traveled widely to assist festivals: ethnic groups in Ohio, Cajun bands in southern Louisiana, border organizations in El Paso, Ukrainian-Americans in New Jersey, Appalachian mountain folk in Tennessee. Lee became at home with the traditions of the byways, the bayous, and the blue line highways.

An elevator operator in the council's office building also was a maker of moonshine, appropriately a part of America's folk culture. Once a month,

he brought the Traditional Arts staff a gallon of his product. At the time, Stewart's office was nearby in downtown Washington. Wilson tells how Lee would pour some of the white lightning into a smaller container and dilute it "to save Stewart," who would come over after work to "hang out" with the office staff before driving Lee home.

One of the memories of Lee's fun-loving spirit that Wilson cherishes occurred at a Tennessee dogwood festival, where a National Park Service employee—full of himself and his musical ability—inspired Lee to spin a tale of her talent with the recorder (a rudimentary wind instrument often played by elementary school pupils). She convinced the parks guy that she was a world-class performer on the recorder. Then, when the blowhard began telling Lee about the Park Service, Joe Wilson heard her reply, "Yes, my husband used to own it."[8]

After several years with the council, Lee joined Wilson in researching and writing *Folk Festivals: A Handbook for Organization and Management*, "for those who wish to present the carriers of folk traditions in festivals that are accurate and respectful in depicting folk culture." The coauthors provided guidance for the sponsors of new or ongoing festivals, primarily based on case studies of celebrations that Lee and Wilson had observed. The University of Tennessee Press published the book.[9]

Lee's affection for American vernacular culture extended to that of western ranch hands, and this led to her friendship with Van Holyoak from Arizona. The soft-spoken rancher, folksinger, and storyteller made his home on a small spread at Clay Springs—a wide spot on the road some sixty miles west of St. Johns. Their first meeting was when Lee was helping run the National Folk Life Festival at Wolf Trap Farm. It was Holyoak, according to Joe Wilson, who considered Lee "the greatest thing since sliced bread." The late cowboy musician "simply adored" Lee.[10]

In addition to Lee's involvement in America's traditional folk arts, both Udalls continued to enjoy their contacts with the greater world of the arts in general. Stewart recalls, as an example, that Lee (but not himself because he had a commitment elsewhere) accompanied Robert Lowell by train to Connecticut for a Bill Meredith birthday party. Among the guests, Stewart says, were playwright Arthur Miller and his then wife, photographer Inge Morath. He adds, "We developed a wide range of friends in the arts—poets, musicians, Broadway people, and so on." Nevertheless, by 1979 Washington

was no longer the place for Stewart. "I was in danger," Udall said, "of becoming a member of that group of ex-government exiles who, instead of being gone but not forgotten, were in danger of being forgotten but not gone." Life in the capital had been good, however, and "we left a legacy for Washington, and for ourselves."[11]

"They Saw the Arts as Indian People Do"

STEWART AND LEE MOVED TO PHOENIX, possibly with a view to seeking a congressional or senate seat, but the political face of Arizona had changed with the arrival of hundreds of thousands of new residents. For a Democrat with a reputation as a liberal, the outlook for electoral success was dim. Stewart continued with his law practice, soldiered on with his suits for the radiation victims, lectured on ecology and energy, and in his words, became a "citizen activist."

Being a "citizen activist" wasn't really enough. Stewart needed something more, and two remarkable women, Sandra Day O'Connor and Jacqueline Kennedy Onassis, helped provide that something, separately.

In Phoenix, the Udalls lived near the Heard Museum, and both Lee and Stewart joined the advisory board of that outstanding museum of Native cultures. Stewart wrote a note to the museum president, Mrs. O'Connor, then an Arizona judge, proposing that the museum sponsor a tour to his northern Arizona homeland to meet the Indian artists and craftspeople whose works the museum champions. The future U.S. Supreme Court justice replied, "Good idea, Stewart. Why don't you lead the trip?" This appealed to Udall and he welcomed the opportunity to guide a three-day tour. His easy familiarity with the history and culture of northern Arizona's Colorado Plateau became recognized and induced *Arizona Highways* magazine to invite him to write an article about his home region. Following its publication, Stewart—"in my usual bold way"—sent a copy to his friend Jacqueline, an editor at Doubleday, suggesting, "Maybe we could turn it into a book." She showed interest, and Stewart asked if she had ever seen his Southwest. She had not.[1]

A week's journey via four-wheel drive vehicle resulted. Lee and Stewart led the former First Lady and her friend Maurice Tempelsman through rugged mountains and across the high desert plateau to the prehistoric Indian settlements that Francisco Vásquez de Coronado and his company encountered four hundred years earlier during the first European exploration of the region. Wearing blue jeans and a wide-brim hat for sun protection, the former First Lady waded across the knee-deep, chilly waters of Arizona's Black River in Apache country, met the residents of the ancient village of Acoma atop its New Mexico mesa, and toured the still-lived-in pueblos along the Rio Grande. "We had a wonderful relationship," he recalls. In a note afterward, Jacqueline wrote, "I have never spent such happy days nor been so absolutely knocked out by the beauty of all that we saw. . . . I'm glad I waited until life gave me the great gift of seeing it all with you."[2]

With Jacqueline Kennedy Onassis's encouragement, Stewart proceeded with a book. He teamed with Arizona photographer Jerry Jacka to explore all of the conquistador's travels from northern Mexico through Arizona to Santa Fe and beyond into central Kansas and western Texas. The result was *To the Inland Empire: Coronado and Our Spanish Legacy*, published by Doubleday in 1987 in a large format with outstanding color photos by Jacka and a substantial text by Udall. Without a doubt, the book was born out of Stewart's childhood. In the opening he wrote:

> An exciting thing happened when I was growing up in a remote area of my native state. This was the revelation that the 1580 expedition of conquistador Francisco Vásquez de Coronado had passed by my home town of St. Johns, Arizona, on its quest to find the "golden cities" of Cibola. . . .
>
> I was told that Coronado's trail came by St. Johns as it paralleled the wagon road that later ran from Fort Apache to the Zuni Indian Reservation. To a child growing up in a lonely land, these revelations were like a fairy tale dropping out of a book into life.
>
> Sometime when the spring winds were roaring, I would stand and listen. In my imagination I could hear the clang of Spanish armor rising across the hills from the west. . . . These were the fantasies of my childhood and youth, and they lit a lamp of speculation that flickered on and off as long as I lived in St. Johns.[3]

The thrill and wonder of that childhood romance with the past had stayed with Stewart, and eventually, he found the opportunity to follow through, to explore and write about Coronado and the Spanish trail of exploration. Stewart wanted to share with others that often-overlooked Spanish colonial chapter of United States history.

For his book jacket blurbs a variety of Udall friends—Barry Goldwater, Arthur Schlesinger, Jr., actor Robert Redford, and television commentator Eric Sevareid—contributed praise. The message of Udall's book won favorable notice at the highest echelons in Spain. To honor Udall for his devotion to advancing knowledge of Spain's North American history, King Juan Carlos knighted him, investing him with the Order of Isabel the Catholic.[4]

The book's success gave Stewart a second wind as a book author, and he wrote on. In 1988 he transformed his best-selling first book into an updated and enlarged new edition, *The Quiet Crisis and the Next Generation*. Stewart had rediscovered his métier, and there would be more volumes to come.[5]

Nevertheless, knighthood meant little in Phoenix where a newspaper writer believed that Stewart was a "prophet without honor in his own land." Writing in the *Arizona Republic* in the summer of 1989, James Bishop, Jr., reported that "any day now, Phoenix residents will awake to find that one of their natural resources has vanished during the night. . . . Stewart L. Udall will have pulled up stakes and moved to Santa Fe, N.M. The reason is simple enough: quality of life. . . . [Udall] has had it with Phoenix—with the city's pollution, the polarized legislature and the absence of a community vision."

Other than the Heard Museum and Frank Lloyd Wright's Taliesin West studio and home, Udall was quoted by Bishop as declaring that Phoenix lacked "places of distinction and culture." To become a great city, Udall contended, "Phoenix needs more than sports franchises." Few Phoenicians seemed to listen. Bishop concluded, "He has been evidently regarded by the powers that be as just another worn-out warhorse. Either that, his friends say, or local leaders are unable to recognize a national monument when they see it."[6]

For several years, Lee and Stewart had escaped the heat of Phoenix by renting a house in Santa Fe for the summer. In 1989 they relocated to the New Mexico city, buying land for a new, permanent home on Santa Fe's outskirts, at the base of the Sangre de Cristos. They subdivided the property, retaining a portion for themselves and a homesite for son Tom, who was beginning to make political waves in the state. The Udalls divided the remainder of the

land into a few lots for sale. "Imagine," Stewart said to Polly and me, "I'm a developer!"[7]

A crossroads of cultures, Santa Fe in its small, unique way is filled with artists and craftspeople, as well as anthropologists, poets, historians, and writers; there are museums and dozens of galleries and the famed Santa Fe Opera. It was the right place for Stewart and Lee, perhaps especially for Lee. Although there were Indian reservations near Phoenix, the city was becoming a metropolis with little evidence of present-day Indians. In Santa Fe one could feel the continuing presence of Indian culture. The town was more comfortable for the Udalls than Phoenix, despite the friends they had to leave behind. When the Museum of New Mexico named its Museum Resources Building on Santa Fe's "Museum Hill" for him, Stewart declared, "That completes the New Mexicanization of Stewart Udall."[8]

For Stewart there remained one bit of Interior Department tradition that needed to be fulfilled. After each secretary's service ends, the department commissions an artist, chosen by the subject, to paint an official portrait; the works are displayed in the building. In 1969, shortly after Stewart left office, Paul Horgan wrote to Udall, suggesting that Peter Hurd do his portrait; he then reported that Hurd had "enthusiastically responded" to the idea. To sit for the portrait, Horgan noted, probably would require a few days at Hurd's San Patricio ranch in New Mexico. Udall declined, "I only wish I had the time right now to spend a few days at San Patricio," but that time had not come.

Eventually, Stewart found the time, and Lee suggested the portrait be done by an Indian artist. They selected Allan Houser, of Apache ancestry, who had taught at the Institute of American Indian Arts. (According to Stewart, this angered Navajo artist R. C. Gorman: "I'm a painter! Houser's a sculptor!") When Stewart posed, he was no longer the crew-cut young man he had been when appointed secretary. His graying hair was much longer, sometimes tied in the back with a cord. Houser's informal portrayal placed Udall in a Four Corners landscape and, in my view, emphasized the "Indian-ness" of Stewart's facial structure—high cheekbones, strong and slightly hooked nose, firm chin—approaching the stereotypical "Indian look."[9]

If a good portrait should capture the inner spirit of the subject, Houser may have succeeded admirably. At times there seems to be something inscrutable about Stewart Udall, and that may fit a naive white person's view of a generic American Indian. Neither Stewart nor Lee is of Indian ancestry (her blonde

hair and light complexion would tend to erase such thought), but both related easily to Indians. Even when newly married, Lee began, within their limited budget, to decorate their home with southwestern art. Their Santa Fe friend Jim McGrath, an artist and educator who worked with students from many Indian nations, observes, "The Udalls saw the arts as Indian people do—arts, drama, the whole works—the spiritual influence."[10]

The Udall move to Santa Fe plunged Lee into still more activity in Indian arts education. She saw a need to bring contemporary musical experiences to southwestern Indian youth, and a desire to have classical music masters perform for audiences of young Indians inspired her to bring the New York City–based Dorian String Quartet to schools operated by the Bureau of Indian Affairs (BIA) on the Navajo reservation. Lee also found the means to sponsor a quartet from the Phoenix Symphony in performances on the reservation. With Bureau of Indian Affairs and Institute of American Indian Arts support, plus funding from the Ford Foundation through her Center for the Arts of Indian America, she challenged Jim McGrath to develop a traveling multicultural program to visit the reservation schools across Arizona. A van transported artifacts, musical tapes, and two cultural motivators, Pima artist Frances Makil and former Peace Corps arts specialist Leona Zastrov, who urged schools to expand their curriculum based on Indian cultural elements. Three publications resulted, "Dance with Indian Children," "My Music Reaches the Sky," and "Art and Indian Children."[11]

Lee's persistent efforts to broaden Indian arts education resulted also in a traveling exhibit of ancient and modern Indian art intended primarily to educate and inspire Indian children. The exhibit was created by the Laboratory of Anthropology of the Museum of New Mexico and mounted in a semitrailer. For two years, anthropologist-author Jack Loeffler accompanied the rolling museum to sixty-three schools scattered across the giant Navajo reservation in Arizona, Utah, and New Mexico. In addition to its intended goal, it was the beginning of an enduring, close friendship between Loeffler and both Udalls.[12]

In the early 1990s Lee was diagnosed with breast cancer, but after treatment it was believed that the disease had gone into remission. She was eager to move on, and she undertook a journey into the Sierra Madre of Mexico to locate indigenous art objects that would supplement an IAIA exhibit displaying the linkage of a people, their art, and their environment. Lee trekked

deep into the mountainous backcountry of Chihuahua, Mexico, with Jack Loeffler and his friend Karl Kernberger. They found ancient and contemporary artifacts of the Tarahumara Indians for the exhibit. They also visited the village of Mata Ortiz, Chihuahua, then in the early stages of its fame as the home of scores of potters who produced imaginative thin-walled pots inspired by, but no longer mere copies of, the decorative pottery discovered nearby in the partially excavated prehistoric community of Paquimé, also known as Casas Grandes.

Innovative architect Paolo Soleri, once a student at Frank Lloyd Wright's Taliesin West, was persuaded to come from Arizona to design an amphitheater at the IAIA's Cerrillos Road campus. When a conference of folk artists was in town, the completed amphitheater was the scene of an event to raise funds to pay the continuing costs of the radiation victims' law suits. Pete Seeger and Ed Abbey agreed to meet with the Udalls at Loeffler's home to plan the benefit. The Udalls arrived early and went into his backyard, Loeffler recalls. Then simultaneously, he says, both Udalls came back in through a rear doorway, the political folksinger walked in another door, and the environmental polemicist entered through a third. It could have been a scene from a play. This was Santa Fe, and for Lee and Stewart it fit.[13]

The concert raised seven thousand dollars. R. C. Gorman donated one of his enigmatic, boldly colored portraits of an Indian woman. The Udalls arranged for lithograph copies, which sold well, adding forty thousand dollars to the fund for pursuing the radiation cases.[14]

Stewart turned seventy in 1990, soon after the Udall's move to Santa Fe, but that did not slow him. His law practice was making money, and he seemed to be hitting his stride as a writer of history. He joined with four coauthors—William Kittredge, Patricia Limerick, Charles Wilkinson, and John Volkman—in writing *Beyond the Mythic West*, intended to lead readers beyond the "cowboys and Indians West" to a broader understanding of "the real West" and its future. The book was a version of "the New Western History," an innovative approach to interpretation of the West, an antidote to what Wallace Stegner deemed "isn't history at all, but myth, the Diamond Dick kind of stuff." The Western Governors Association sponsored the publication.

When asked now if he considers himself one of the "New Western Historians," Udall's reply is a quick, emphatic "Yes." Then, as an indication that he believes some New Western historians might not agree, he adds: "I'm a

debunker—but I'm just adding a room to the mansion." Stewart mentions with obvious satisfaction that, after the book's appearance, one of his coauthors, Dr. Patricia ("Patty") Limerick, often considered the doyenne of New Western historians, began using *Quiet Crisis* in her classes at the University of Colorado. She invited Stewart to visit the Boulder campus and, after she was his host there for two days of lectures and talk sessions, told him that his presence was "a highlight of my life."[15]

In 1992, Professor A. Dan Tarlock of Chicago-Kent College of Law returned to Udall's first book to see how the author's ideas had fared since its publication. In an *Arizona Law Review* essay, "The Quiet Crisis Revisited," Tarlock decided that "although its conclusions were too optimistic," Udall's book had stood the test of time. "[It] endures . . . because its historical focus is right and Secretary Udall accurately predicted the lasting influence of ecology in domestic and global resource use debates." Tarlock called him "the literary Stewart Udall" and believes the book "will always occupy an honored place on the small shelf of books which have shaped popular attitudes that continue to fuel the environmental movement." Tarlock contended that, along with Aldo Leopold's *A Sand County Almanac* and Rachel Carson's *Silent Spring*, Udall's *Quiet Crisis* "contributed to a fundamental change in the way in which we think about our resource heritage." Good company, and high praise indeed.[16]

Udall returned to the Spanish colonial period in the Southwest with *In Coronado's Footsteps*, a reworking of his *Arizona Highways* article, published to benefit national parks of the West. Then, in 1993, to assist his nephew Randy, a budding writer and one of Mo's sons, Stewart lent his name as coauthor of two illustrated publications: *Arizona, Wild and Free*, featuring the state's wilderness areas; and *National Parks of America* with Randy Udall and photographer David Muench.[17]

History drew him on. Although Stewart had said, "I've always been a questioner," it took decades for him to question, and reverse, the views on nuclear energy that he expressed in 1963 in the pages of *Quiet Crisis*. Then, he praised nuclear power, calling atomic energy development "the supreme conservation achievement of this century," predicting that reactors would "breed energy from rocks." He wrote not a word about the disposal of nuclear waste. (Sharon Francis calls that chapter of *Quiet Crisis* "a hymn to nuclear power," and says it was the part of the book that disturbed her.) Years later, the effects of the atomic rush on the peoples of his own heartland—the

Navajos and the heavily Mormon communities of southwest Utah and adjacent Nevada—brought a 180-degree change in Udall's thinking. His eyes were opened as he pursued litigation on behalf of radiation victims: Navajo uranium miners and the downwind victims of radiation poisoning from the Nevada atomic bomb tests.[18]

Udall's legal work for the miners and the other victims educated him to the continuing human costs of uranium mining and nuclear testing. Disillusionment set in and Stewart admitted he had been mistaken when he praised nuclear energy in *Quiet Crisis*. Ultimately the suits against the government failed, but a legislative remedy awarded limited compensation to the victims of governmental deception about the hazards of nuclear energy. Udall's work did not end there; more than twenty years after the first suits were filed, he was continuing to seek out the victims and their descendants and help them verify claims for the congressionally authorized compensation for the victims of what he called "the radiation tragedies of the 1950s."

Udall's research efforts for the radiation victims forced him to struggle through a bureaucratic thicket of misdirection, misstatement, and deception. It took three decades for him to decide that the favorable views of nuclear energy that he expressed in 1963 were in error. He uncovered half-truths and hidden truths that accompanied America's atomic energy program, and that led him to write another book.

In his 1994 book, *Myths of August*, Udall revealed the denials and deceptions that accompanied America's atomic energy experimentation and development. He refuted the myths, showing that the benefits had been overstated and the hazards underestimated or concealed. He challenged the national security justification for the spread of government secrecy—"Big Lies." In America's fascination with the atom, he argued, our nation "paid a heavy moral and political price by ignoring the open-government commands of the Constitution." He asked, "What were the influences that pushed America's once-prized moral principles into the background and encouraged our leaders to approve Cold War modes of conduct here and abroad that diminished our claim to moral leadership?" His words foreshadowed more recent events: "clandestine decisions" led to "a spectacular mistake." That mistake, as he saw it, was "to confine decision-making to the president and a tiny coterie of 'wise men.'"[19]

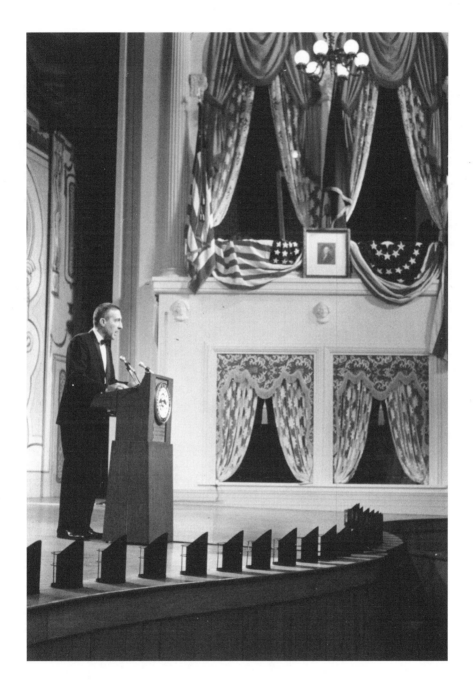

With the flag-draped Lincoln box behind him, Stewart Udall spoke at the gala reopening of Ford's Theatre on January 30, 1968.

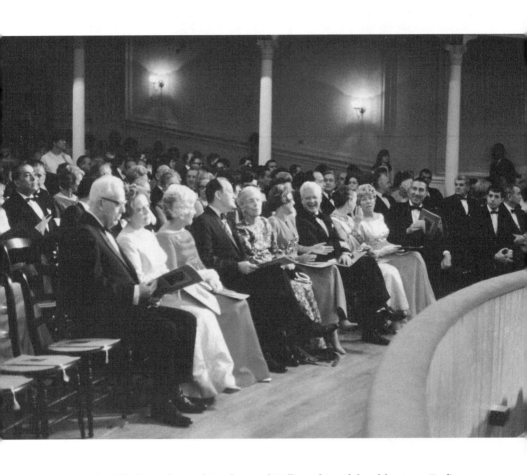

Political leaders and stars of Broadway and Hollywood joined the celebration at Ford's Theatre. Among the front-row guests were Chief Justice Earl Warren; his wife, Nina Warren; Vice President Hubert H. Humphrey; and his wife, Muriel Humphrey.

Mrs. Stewart L. Udall, wife of the Interior Secretary, and James McGrath, assistant art director of the Institute of American Indian Arts, Santa Fe, N. Mex., discuss the exhibits being installed in the Interior Department's Art Gallery. A workman at right holds "Mic- cosukee Village," by Carol Lee Frazier, a student at the Santa Fe school. The Gallery will open to the public May 12.

Indian Exhibit Will Restore Interior's 'Lost' Gallery

A Washington Post *article announced the resurrection of the art gallery at the Department of the Interior. Helping Lee Udall prepare for the opening was Jim McGrath of the Institute of American Indian Arts in Santa Fe.* Clipping courtesy of Jim McGrath.

Children's arts of many varieties from dozens of Indian schools were a part of the first show at the reopened Interior Department gallery. Interior Department photo.
Courtesy Special Collections, University of Arizona Library.

Standing with Stewart and Lee Udall, famed potter Maria Martinez of San Ildefonso Pueblo, New Mexico, visited the Interior Department gallery with her son, Popovi Da, and grandson, Tony Da. COURTESY SPECIAL COLLECTIONS, UNIVERSITY OF ARIZONA LIBRARY.

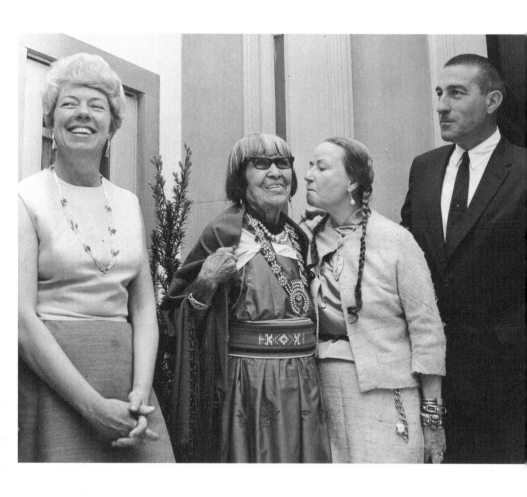

Flanked by the Udalls, Osage artist and author Yeffe Kimball greeted Maria Martinez at the art gallery. Courtesy Special Collections, University of Arizona Library.

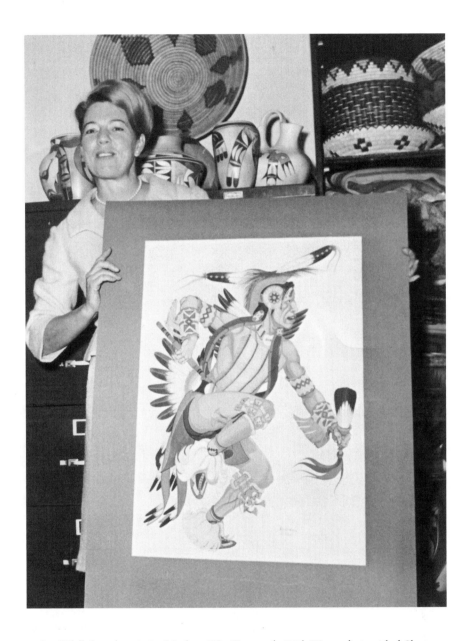

Lee Udall chose the painting Modern War Dancer, *by Dick West, a distinguished Cheyenne artist, for an early show at the gallery, November 15, 1964. Interior Department photo.*

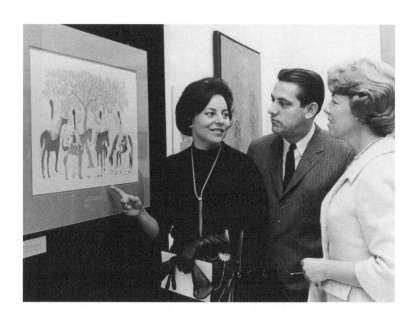

▲ Oklahoma senator Fred Harris
and Mrs. (LaDonna) Harris
were among the visitors welcomed
by Lee Udall to the art gallery.
COURTESY SPECIAL COLLECTIONS,
UNIVERSITY OF ARIZONA LIBRARY.

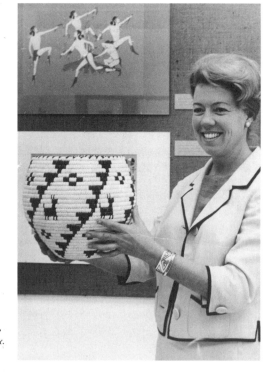

▶ Lee Udall admired a large
example of Indian basketry
on exhibit at the gallery.
Department of Interior photo.
COURTESY SPECIAL COLLECTIONS,
UNIVERSITY OF ARIZONA LIBRARY.

Photographer Ansel Adams and Lee Udall stood in front of Adams's Moonrise, Hernandez New Mexico, 1941, *at a non-Indian show at the Interior Department gallery featuring his works.* COURTESY SPECIAL COLLECTIONS, UNIVERSITY OF ARIZONA LIBRARY.

Lady Bird Johnson greeted dancers from Apache reservations in the East Room
of the White House. She and the performers were accompanied by Lloyd Kiva
New of the Institute of American Indian Arts and the Udalls. White House photo.
COURTESY SPECIAL COLLECTIONS, UNIVERSITY OF ARIZONA LIBRARY

Lee and Stewart Udall, Julie and Harry Belafonte, and Ethel and Robert Kennedy enjoyed an evening at Carter Barron Amphitheater in Washington's Rock Creek Park. Photo by Abbie Rowe, National Park Service. Courtesy Stewart Udall.

▶ Following page: *Lee Udall volunteered to update the library at Blair House, the official White House guest quarters for distinguished visitors.* Courtesy Special Collections, University of Arizona Library.

Lee Udall, the mother of six children, seemed to like all children. She enjoyed leading youngsters on the towpath of the C & O Canal beside the Potomac. National Park Service photo. COURTESY SPECIAL COLLECTIONS, UNIVERSITY OF ARIZONA LIBRARY.

On the trail of Coronado, the Udalls, Jacqueline Kennedy Onassis, and her friend Maurice Tempelsman forded the Black River in eastern Arizona's Apache country. Their excursion was a prelude to Stewart's writing To the Inland Empire. Photograph by Jerry Jacka. COURTESY OF STEWART UDALL AND JERRY JACKA.

High atop a fortresslike mesa in New Mexico, Lee told Jacqueline Kennedy Onassis about the historical significance of Acoma Pueblo. Stewart Udall says photographer Jerry Jacka avoided taking full-face photos of the former First Lady because "he felt she'd had enough of that." Photo by Jerry Jacka. COURTESY OF STEWART UDALL AND JERRY JACKA.

Stewart's brother and successor in Congress, Representative Morris ("Mo") Udall, and Senator Henry ("Scoop") Jackson (D., Wash.) unveiled the Allan Houser portrait of Secretary Udall at an Interior Department ceremony in April 1977. Photograph by Bob Coles, Department of the Interior. COURTESY STEWART UDALL.

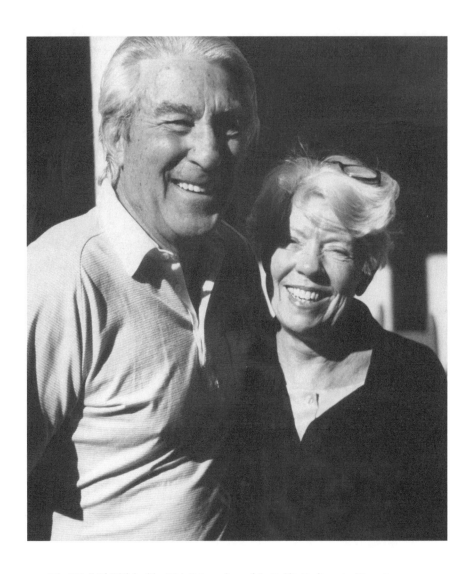

The Udalls' folklife buddy, Nick Spitzer, host of the Public Radio series "American Routes," photographed the happy couple at their home in Santa Fe in 1994.
Courtesy Stewart Udall.

"She Carved out Her Own Legacy"

LEE AND JACK LOEFFLER, and Stewart as well, planned a research and collecting trip to the islands and coast of the Gulf of California (romantically called "The Sea of Cortez"), location of the settlements of Seri Indians, creators of notably artistic ironwood carvings of land and sea animals. En route to the Mexican coast, however, some instinct caused Lee to stop in Tucson for a checkup first, and it was discovered that her breast cancer had not been totally eliminated. Despite surgery and other treatment, the disease had been slowed but not conquered. Immediate action was called for, and the journey into Mexico was cancelled.[1]

By the spring of 2001, however, the outlook for her recovery was not encouraging and she became a hospice patient in Santa Fe. Then, a welcome surprise: Lee rallied. A heartened Stewart gave her a poem he wrote to celebrate her progress:

> *The Undaunted Hospice Patient*
> *For Lee*
>
> Would she last until Easter?
> She would.
> Would she persevere to her next birthday?
> She would.
> Would she be there to see newborn Rachel?
> She was.
> Mystery has no domain here.
> Where there is indomitable love
> Death has no dominion![2]

During the months of Lee's illness, Lee's folk-festival friend and coauthor Joe Wilson suggested to Robert ("Tree") Cody, a com-

poser and world-traveled flutist of Dakota-Maricopa heritage, that he create a melody honoring Lee, "my pal and co-worker." Cody, according to Wilson, cautioned that "tunes honoring people did not come automatically. But the next morning he told me that something woke him at 2 o'clock. A melody had come to him in the night . . . filling his head so that he had to write it then." In a compact disc of Cody solos that Wilson produced, *Siyotanka: Courting Flute of the Northern Plains*, Cody included his "Love Song for Lee." It is a hauntingly beautiful and appropriate tribute to a woman who cherished and nurtured American Indian culture. Wilson had hoped to give the just-completed CD to Lee for Christmas, but it was not to be. The cancer was not defeated. Lee died on December 23, 2001.[3]

Lee's memorial service brought scores of friends to the Cerillos Road amphitheater. Each person received a four-page illustrated memento, "A Celebration of Life." On the front was this message: "Lee was a poet's blessing. Two of her children, Lori and Jay are poets. Her son Jay shares his poem with us in this Celebration of Life."

Mother

Shepherd of wayward jackets,
straightener of shoes and attitudes,
queen of insomnia,
fatherless five-year-old,
mother to every lost child
except yourself,
your hands worked so hard
to set things right
as close as love could come

Jay Udall[4]

The back of the memorial keepsake bore "A Prayer for Lee Udall," by N. Scott Momaday, honored member of the Kiowa Gourd Clan, artist and Pulitzer Prize–winning writer. His first stanza:

Great Spirit,
keep her memory,
keep her memory in the hold of the wind,
in the bright warmth of the desert morning,

in the cool of canyon dusk,
in the music of mountain waters,
in the dancing of silver leaves,
in the glitter of the night sky. . . .

—N. Scott Momaday.[5]

Stewart believes that "Lee had an enormous part in the flowering that has taken place in Indian art." When he donated papers to Special Collections at the University of Arizona Library in 1989, he included some of Lee's papers, with a note: "I have always felt that Lee accomplished more meaningful things as a cabinet wife than any of her contemporaries. She reopened Secy. Ickes's art gallery, was a godmother to many budding Indian artists, and set up a scholarship program for Indian artists. These papers I gleaned for [sic] some of the files she kept!" Stewart told me, "She was very modest about her role." He recalls her saying, "I don't need any recognition. . . . The people who are important to me already know what we've done."[6]

Native Peoples Magazine called Lee "a matriarch of Native art and culture. . . . A major force behind the success of the Institute of American Indian Arts . . . [she] worked tirelessly to promote a wider appreciation for Native peoples and art among media and major cultural institutions nationally and globally." Jack Loeffler believes that in arts education "Lee affected thousands." Because of the institute's growing influence, the IAIA states that "a flood of art now pours out from Indian artists all over America." The IAIA is now an accredited degree-granting two-year college with a museum of contemporary Indian arts not far from the Plaza in Santa Fe. Despite her desire to avoid publicity about her activities, Lee earned the praise that came her way.[7]

Pioneering IAIA administrator Lloyd Kiva New wrote of Lee: "She befriended, counseled, and provided scholastic assistance for numerous IAIA graduates . . . at such prestigious institutions as the Juilliard and the San Francisco Art Institute." He summarized, "Lee opened doors."[8]

Three former officials of the IAIA, interviewed separately in 2003, succinctly depicted Lee's abilities:

James McGrath: "She found the funds to make things work."

Louis Ballard: "There was no limit to her imagination."

Dave Warren: "She was a creative genius."[9]

One of Lee's folklife buddies, Nick Spitzer of New Orleans, folklorist host of the "American Routes" program on public radio, declared, "Whether conversing about a cultural policy for Amtrak or counting blue herons and house finches on the Eastern Shore, Lee's voice and vision continue with all who knew her and many who didn't."[10]

In a Phoenix newspaper obituary, reporter Connie Cone Sexton took special note of another facet of Lee's life, observing that she made a special niche for herself, in addition to being a wife and mother. Lee, the reporter noted, "discovered how not to dissolve into her husband's shadow. While she supported his political career, she carved out her own legacy, not only as a strong mother and family advocate but as a champion for Native American art."[11]

"*Manifest Destiny Was a Glib Slogan*"

In the late 1990s Lee's health was Stewart's major concern, although he necessarily remained heavily committed to the radiation suits. When he could find time to do so, however—"for seven years on and off," he says—he pondered and refined his thoughts on the history of the American West. It disturbed him that even today many westerners persist in a pervasive, romantic, simplistic view of a violent "Wild West," choosing to accept a fanciful past rather than acknowledge the less exciting but more realistic narrative of the early West. The generally accepted violent image of the region did not fit with his own background and experience, and he struggled to refine his own different view of the region. Study and introspection led to *The Forgotten Founders: Rethinking the History of the Old West*, his next and, so far, latest book, published in 2002.[1]

When Dan Tarlock's laudatory essay, "*The Quiet Crisis* Revisited," appeared, Stewart mailed a copy of the essay to Polly and me with an inscription: "You see, I'm now a certified intellectual."

That reveals something about Stewart as a native of the Southwest—an underlying regional sense of inferiority difficult for westerners of long heritage in the area to overcome. Perhaps Buffalo Bill should be blamed. He was far too successful in promoting the idea of a Wild West—Udall calls him "a consummate showman," and he even outdid P. T. Barnum as a promoter. Buffalo Bill's phrase "Wild West" and the concept behind it has been repeated and accepted by westerners themselves. The consequence is a view that culture, high culture, does not exist west of the Pecos, or the Missouri, or maybe even west of the Mississippi.[2]

Overcoming that distorted view seems to be difficult; evidence of perceived inferiority continues to appear. A Tucson newspaper

demonstrated that attitude with a defensive editorial citing Udall's friendships with Frost and other cultural icons and his launching of the Cabinet Artist Series as evidence "that should persuade the most hide-bound Easterner that cultural interests do exist in the West." At a memorial service for Wallace Stegner sponsored by western historians, Stewart felt it necessary to challenge the literary judgment of "effete mandarins of the East" who, he believed, discounted the work of his friend, mentor, and fellow westerner.[3]

Hindsight reveals the irony of the Udalls' home-state presence in the Kennedy inaugural parade: Stewart and Lee Udall chauffeured in splendor, accompanied by the nation's beloved poet. But then, farther back in the parade, Arizona's official entries: a "Tombstone" float featuring the central figures of the so-called "Gunfight at the OK Corral"—Wyatt Earp and "Doc" Holliday—with depictions of "Boot Hill" and a gallows. The float was escorted by a band of thirty bearded and buckskin-clad "Bill Williams Mountain Men" recreating frontier trappers brandishing muskets and leading pack mules. Back home, Flagstaff's *Arizona Sun* boasted that the "Mountain Men" proved to be a popular "sensation," and the *Tucson Citizen* decided that the "Arizonans painted a realistic picture of the old frontier."[4]

History is handicapped when myth arrives first.

Stewart showed that he was subject to the spell of the myth when he wrote *Quiet Crisis*; he hailed the frontier trappers: "The toughest . . . would tackle the Indian and the elements, become the most competent outdoorsman in our history, and write the boldest chapter in the winning of the West." Udall also expressed his admiration for the late Bernard De Voto, declaring that his narrative histories of the era of "Manifest Destiny" provided "a superb description of the Spartan demands of the frontier." Stewart did not question De Voto's view that, in Mexican California and at the British trading posts in the Oregon country, the arrivals of the first mountain men from the United States in the 1820s were epochal events, "rude announcement of America's 'Manifest Destiny.'" At the time Udall wrote *Quiet Crisis* he accepted the idea of "Manifest Destiny" as the force behind the settlement of the West.[5]

Udall-as-historian matured in the decades that followed the appearance of that book. "My crash course of study at Interior [beginning with Stegner] . . . encouraged me to ponder the patterns of settlement and the turning points of my region's history." After his cabinet service, Udall continued studying and reflecting on America's past and, once he was back in the Southwest, his study

led to a drastic revision of his earlier opinions. He changed his views on the mountain men and De Voto's approach to history. In *Forgotten Founders* Udall came down hard on De Voto, charging that his works were "permeated with racism and steeped in stereotypes peddled by Wild West writers." De Voto "was a superlative writer," Udall admits, but "he stretched history when he portrayed the crude, mostly illiterate beaver trappers . . . as 'conquerors' who somehow 'bequeathed' a tamed West to the families who came . . . to build homes and communities." The evidence, Udall writes, does not support the view that the mountain men were "farsighted 'agents of empire,'" nor does he concur in De Voto's view that the early men and women who trekked into wilderness and created communities in virgin valleys considered themselves empire builders. "'Manifest Destiny,'" Udall declares, was "an illusive doctrine . . . a glib slogan."[6]

Forgotten Founders is an expansion and refinement of Udall's briefly expressed theme in *Beyond the Mythic West*. In his opinion, too many histories of the region put the wrong people at the center and emphasize "the mythology of Western violence," resulting in what he derides as "the Wyatt Earp approach to history." The true representatives of the "Old West," a term he prefers over "Wild West," are its settlers, hard-working, generally peaceful folk of diverse origins (and he includes Indians) who made the West what it is. In his opinion, the bedrock foundation of western American history is composed of settlers—not cowboys, outlaws, and lawmen; hostile Indians; stagecoach robbers; and other types familiar to consumers of fictional "Westerns" and many nonfiction accounts of the West. Stewart's western heroes are the farmers, ranchers, merchants of many ethnic and racial backgrounds—solid citizen-builders of communities.[7]

"Community" means much to Stewart, and in some respects, he is never far from St. Johns. This became apparent at one luncheon discussion in his dining room at Interior when table talk turned to rural communities and the benefits of growing up there. Stewart asked how many of the men around the table (no women were present that day) lived in small towns in their youth. Each one of us raised his hand, and Stewart thought that was great.[8]

De Voto's romanticized view of the West, Stewart contends in *Forgotten Founders*, "led him to ignore ordinary settlers . . . [for] characters he deemed more colorful. . . . No one has done more to belittle the accomplishments of the wagon settlers." Udall credits the wagon settlers with providing the basis

of western development. His Mormon heritage is quite evident in *Forgotten Founders*. Among the wagon people were the Mormons, and Udall cites his Mormon great-grandparents as examples of the God-fearing, hard-working builders of western communities—less colorful than De Voto's frontiersmen, but far more significant.[9]

One of Stewart's great-grandfathers was John Doyle Lee. Therein lies an irony in Stewart's contention that violence was not a significant part of pioneer life in the West. Those familiar with Mormon history know that Major Lee, whom Udall describes as "a ground floor Mormon . . . a stalwart lieutenant" of Brigham Young, was far from being a colorless figure. As a Mormon militia major in southwestern Utah in 1857, John Doyle Lee participated in an ambush of a California-bound wagon train of prosperous emigrants from Arkansas, thirteen families plus some single men. Among more than one hundred people in the train, fewer than twenty children were permitted to live. The event—known as the Mountain Meadows Massacre—was one of the bloodier episodes in nineteenth-century American frontier history. The reasons cited for the murderous attack at a place called Mountain Meadows are complex, and I will not attempt to provide them here, but in *Forgotten Founders*, Udall calls it a "senseless slaughter."[10]

For nearly two decades afterward, the Mormon hierarchy blamed the massacre on Indians, but bits of truth kept emerging; eventually, John Doyle Lee was singled out to be the "sacrificial lamb." Even after he was tried, found guilty, and executed in 1877, the story would not die. Too many people knew or sensed what really had happened, and why. Stewart's mother had been particularly disturbed by the effect on John Doyle Lee's family and descendants, and Stewart writes of her pain as she told him what occurred at Mountain Meadows and the meaning of "scapegoat."

Historians kept nibbling at the story, and some Mormons and relatives of the Arkansas victims began reaching out for reconciliation. Udall joined them. With support of the LDS church, a monument arose at the massacre site, and in a 1991 memorial ceremony at nearby Cedar City, Utah, he did penance for the sins of his ancestor. For Stewart it was "a searing experience," as he expressed in a poem his sorrow for the "unforgivable acts" of the Mormon militia. Through his tears he read the poem he dedicated to his mother:

There was a massacre in these hills.
Four generations have come and gone,
but the deed that haunted the children
that haunted the lives of the militiamen
hovers over the silent land.

Now descendants of the slain
and sons and daughters of the slayers
come, arm in arm, to end the tragic story,
to share a burial rite, perform a
ceremony of atonement.

But how to cleanse the stained earth?
To erase old griefs and grievances?
To quench long-dying embers of anger?
To forgive unforgivable acts?
The balm they bring is love,
the only ointment God offers
To heal wounds too deep for
 healing.[11]

Stewart faced the truth, even about his great-grandfather. It was characteristic of him, an adherence to the goal he had expressed in writing upon returning from war service some forty-five years earlier: a determination to be "true to myself."[12]

Chapter 20 ———————————————————————

"The Heart of a Poet"

Consistently, Udall searches for truths. He sought to counter the rosy, see-no-evil panacea of atomic energy. He cast a clear eye at the overlooked importance of our nation's Hispanic heritage, and he decries the view of his homeland as a crude, violent "Wild West." He is a defier of myths, a teller of truths.

He is a dreamer, too. Udall's concern for "things of the spirit" became evident to journalists early in his secretarial term. And, in a *Saturday Review* article, "The Arts as a National Resource," Stewart stated his hope for a better America when he wrote,

> We have neglected the one realm that in the long run can confer lasting meaning on American civilization and leadership—the realm, in its highest and broadest sense, of the arts. Plainly, a cultural revolution has not kept pace with a scientific and technological revolution. The arts, when they are given the preeminence that they deserve, give insight to our science and renew our aspirations. . . . America, in short, must seek to stimulate any creative process that adds beauty and livability to American society.[1]

Udall contends, too, that Americans have "neglected the environment of the intellect." In an address delivered at Dartmouth College decades ago, he offered thoughts that continue to resonate: "We have, I fear, confused power with greatness. . . . The United States is a powerful Nation. If she is to become a noble Nation—in the sense that Greece and Rome were, for a season, noble—art and philosophy must flourish. Only then will the outward ripple of our culture leave a deposit on distant shores. This can be done if

we create a climate in which the arts and humanities thrive, and individual excellence is esteemed."[2]

Qualified observers—writers, editors, poets, historians—have experienced portions of the lives of Stewart and Lee; what they chose to record helps illuminate the couple's journey. Wallace Stegner uncovered the raw material of a writer/poet in Stewart and showed him how to put a polish on his talents. After their friendship was well established, Stegner sent Udall a Malcolm Cowley verse—"Here with the Long Grass Rippling"—writing that he believed Stewart would appreciate the verse, "being a poet yourself."[3]

Sharon Francis knows. She remains in touch with Stewart and told me: "He has the heart of a poet.... Creativity attracted him.... He sought stimulation and the exchange of ideas with the best and brightest in his firmament: Al Josephy, Wallace Stegner, and his special friend and inspiration, Robert Frost." Too, Jim Reston recalls a visit with the Udalls in Santa Fe and he summarizes: Stewart has "a comfortable relationship with music, art and history."[4]

Jack Loeffler observes that Stewart is "largely enamored of poetry" and tells of a time when Loeffler, seriously ill, was nursed by the Udalls in their home for three weeks. Every evening, Loeffler says, Stewart "would sit by my sickbed, reading poetry to me."[5]

Others see Udall as a sometimes enigmatic man of the West. During his service as Secretary of the Interior, the *Washington Evening Star* called him "the most complex, introspective intellectual in public life." An Arizona newspaper characterized him as "remote" and "prone to talk, not listen." In his foreword to Udall's *Forgotten Founders*, historian David Emmons refers to Udall as being "as essential, as elemental, in his westernness as too little rain."[6]

There is meat in all those views. Yes, Stewart is "complex." He can be genial, humorous, and generous. He inspires loyalty, but intimacy is more difficult to attain. At times he seems lost in a world of his own. He can be brusque, cold, sometimes hurtful. When I was on Stewart's personal staff I respected him but sensed a reserve that kept me at a distance. Now that we are old men, with many of our Interior Department colleagues deceased, the mood has changed—a friendship has grown.

From his schooldays to today, poets have had an attraction for Udall, and poets have responded in kind. Midway in his term as secretary, Udall received a short letter from Archibald MacLeish, a poet who also knew Washington well, having served as Librarian of Congress and as an assistant secretary of

state in the Roosevelt administration. MacLeish wrote Stewart: "You are a wonderful example of a man and an occasion meeting each other with perfect appropriateness and a high degree of effectiveness. I hope you don't mind the unblushing praise—I put it on paper not to please you—you need no praise—but to please myself."[7]

Louis Untermeyer measured Udall and found the essence: "If ever I feared that our relentless progress had prevented a real dedication to the land and the people who often do not deserve it, Udall restored my faith. No one I met in Washington was more culturally alert and more concerned about the human condition than Stewart Udall . . . a stubborn incorruptible in a corrupt world." At another time, Untermeyer and his wife Bryna wrote Stewart, "We have believed in few people, Stewart, as we believe you—and believe in you."[8]

The convergence of Kennedy, Frost, and Udall created a cultural high in the 1960s. Kay Morrison foresaw "the beginning of the age of 'Recognition of Excellence,'" and Kay Halle marveled that "the creative Americans had been considered the equal of the politicians." Some of that euphoria died in Dallas on a November day in 1963. Four decades later, David Emmons declared, "The Kennedy promise was cut short and was quite likely unattainable anyway. But a part of it survived, even flourished. It flourishes still. [Stewart Udall] is for me the perfect and enduring legacy of the Kennedy promise."[9]

For Stewart and Lee, their initial evening "consultation" with Robert Frost in 1959 was the primary ingredient with which they began to create their arts legacies. For Frost, too, the friendship of the young couple was the basis for the international fame that came his way during his last years. After the Kennedy inauguration, when Udall invited Frost to become the first artist to appear on the Cabinet Artist Series, the old poet gushed, "I have been brought out on top of a new pinnacle of view that makes me . . . feel dangerously like a monarch of all the fifty states I survey." The Udalls, he said, had made his life "a real party for the last go-down."[10]

Stewart and Lee brought triumph and happiness to the old poet. And they did their best to help America to understand itself, to appreciate itself, to become a noble nation.

Notes

CHAPTER I

1. Udall interview with author and Polly Hagan Finch (Mrs. L. Boyd Finch), 17 November 2002; Udall phone interview with author, 6 March 2003.

2. *New York Post*, 9 December 1960, clipping, University of Arizona Library Special Collections, Stewart L. Udall Papers, AZ 372, B 242, scrapbook. The Stewart L. Udall Papers, including Lee (Mrs. Stewart L.) Udall material, comprise collection 372, distinguishing them from the Morris ("Mo") Udall Papers. The collection title and number—AZ 372—will not be used henceforth in citations. Subdivisions in 372 are abbreviated here in the manner of B [Box] 242, scrapbook or F [Folder] 1. The family scrapbooks are not dated or numbered, and they are not paginated.

3. Joe Wilson, phone interview, 9 September 2003.

4. Udall phone interview, 17 October 2003; Helen Sekaquaptewa, *Me and Mine: The Life Story of Helen Sekaquaptewa as Told to Louise Udall* (Tucson: University of Arizona Press, 1969).

5. Stewart Udall, "Hometown Values and Hometown Snapshots: Early Days in St. Johns," *American West* (May/June 1982): 27–29; Udall to author, 9 January 2004; reminiscences of Eloise Udall Whiting, B 187, F 1; Donald W. Carson and James W. Johnson, *Mo: The Life and Times of Morris K. Udall* (Tucson: University of Arizona Press, 2001), 16–18, 27; Robert Manning, "Secretary of Things in General," *Saturday Evening Post*, 20 May 1961, 39, 80; Udall to author, 10 December 2002; Pearl Udall Nelson, *Arizona Pioneer Mormon; David King Udall: His Story and His Family, 1851–1938, Written in Collaboration with His Daughter, Pearl Udall Nelson* (Tucson: Arizona Silhouettes, 1959).

6. Manning, "Secretary of Things," 80; Udall address at Founders' Day Celebration, Tucson, 12 March 1965, B 124, F 1; B 226, and B 242, scrapbooks; recollections of the author and Polly Hagan Finch; Udall to author, 10 December 2003.

7. Udall to author, 10 December 2003; "This is not a will," typed document, 7 January 1943, B 226, F 4.

8. Udall to author, 10 December 2002; "Target Time," typed document, B 226, F 4.

9. [Udall], "A Testament: Compiled on the Completion of a War," typed document, B 226, F 4.

10. Jack Loeffler electronically recorded interviews of Lee Udall while she was a hospice patient at the Udall home in Santa Fe, unspecified dates in 2001 (loaned to the author by Stewart Udall and cited hereafter as Loeffler-Lee Udall interview); *Chicago Daily News*, n.d., and (Phoenix) *Arizona Republic*, 23 September 1968, clippings, B 227c, scrapbook; author's recollections; Udall to author, 10 December 2002 and 22 March 2003; Udall phone interview, 20 May 2006.

11. Loeffler-Lee Udall interview; Udall phone interview, 20 May 2006.

12. Udall phone interview, 20 May 2006; author's recollections; Loeffler-Lee Udall interview.

13. Manning, "Secretary of Things," 39, 79–80; Morley Fox, "The Wildcat Lair," *Arizona Wildcat*, n.d., clipping, B 242, scrapbook; recollections of the author and Polly Hagan Finch; Udall phone interview, 20 May 2006; Loeffler-Lee Udall interview; Udall, "A Veteran's Look at the Right-to-Work Bill," reprint from the (St. Johns) *Apache County Independent News*, B 205, F 1; Manning, "Secretary of Things," 39, 79–80; C. L. Sonnichsen, *Tucson: The Life and Times of an American City* (Norman: University of Oklahoma Press, 1982), 306; recollections of the author and Polly Hagan Finch; Udall phone interview 20 May 2006; Martha ("Martie") Proctor Barry phone interview, 20 October 2003; James W. Johnson, *Arizona Politicians: The Noble and the Notorious* (Tucson: University of Arizona Press, 2002), 29.

14. Johnson, *Arizona Politicians*, 28–29; Sonnichsen, *Tucson*, 306.

CHAPTER 2

1. Undated, enclosed with Udall letter to author, 2 December 2002.

2. Author's recollections; "The Udall Home Is Museum of Indian Art," *Washington Post*, undated clipping, B 242, scrapbook.

3. Multiple files, B 206 and B 227; Udall, "Congress Weeps for Lincoln," extension of remarks, *Congressional Record*, 4 March 1959, A1752–53; Udall to author, 27 January 2003.

4. Jeffrey Meyers, *Robert Frost, a Biography* (Boston: Houghton Mifflin Company, 1996), 241, 317; Louis Untermeyer, *Bygones, the Recollections of Louis Untermeyer* (New York: Harcourt, Brace & World, 1965), 215; William McGuire, *Poetry's Catbird Seat: The Consultant in Poetry in the English Language at the Library of Congress, 1937–1987*

(Washington: Library of Congress, 1988), 207–11; Jay Parini, *Robert Frost, a Life* (London: Heinemann, 1998), 408; Thomas G. Smith, "Robert Frost, Stewart Udall, and the 'Last Go-Down,'" *The New England Quarterly* 70 (March 1997): 3–4; Udall interview, 17 November 2002.

5. Udall phone interview, 8 April 2003; Udall interview, 17 November 2002; Udall to author, 6 December 2003; Henry Mitchell, "Robert Lee Frost: A Taste for Irony, An Aptitude for Style, and 'Miles to Go. . . ,'" *Washington Post*, 26 March 1974; Lawrance Thompson, *Robert Frost, the Later Years, 1938–1963* (New York: Holt, Rinehart and Winston, 1976), 271, 276; Lawrance Thompson and R. H. Winnick, *Robert Frost, a Biography* (New York: Holt, Rinehart and Winston, 1981), 408, 478–79; copy of Frank M. Coffin to Udall, 15 August 1994, given the author 17 November 2002.

6. Recollections of author and Polly Hagan Finch. Children's ages deduced from anon., *Lee Udall, A Remembrance* (Santa Fe: n.p., 2002), unpaginated.

7. Udall interview, 17 November 2002; Smith, "Robert Frost, Stewart Udall," 31.

8. Udall, "An Evening with Robert Frost," (Tucson) *Arizona Daily Star*, 5 June 1959.

CHAPTER 3

1. William Beecher, *Wall Street Journal*, undated clipping (December 1960?), and William V. Shannon, *New York Post*, 8 December 1960, clipping, B 242, scrapbook.

2. Meyers, *Robert Frost*, 322.

3. Shannon, *New York Post*, 8 December 1960.

4. Meyers, *Robert Frost*, 322; Thompson and Winnick, *Robert Frost*, 478–79; Smith, "Robert Frost, Stewart Udall," 5.

5. Udall to Kay Morrison, 25 November 1960, and Morrison to Udall, n.d., B 87, F 2.

6. Smith, "Robert Frost, Stewart Udall," 5–7; Irving Brant, *The Books of James Madison with Some Comments on the Reading of Franklin D. Roosevelt and John F. Kennedy* (Charlottesville: University of Virginia, 1965), 12–13.

7. John F. Kennedy telegram to Frost, 13 December 1960, and Frost telegram to Kennedy, 14 December 1960, copies of texts, B 87, F 2.

8. Kay Halle to Eric F. Goldman, 14 May 1974, copy, B 87, F 2; Meyers, *Robert Frost*, 322.

9. Udall phone interview, 31 March 2004; Judith Robinson, *Noble Conspirator: Florence S. Mahoney and the Rise of the National Institutes of Health* (Washington, D.C.: Francis Press, 2001), ix, xii, photos following 146, 160; Thompson and Winnick, *Robert Frost*, 480; Stewart L. Udall, "Frost's 'Unique Gift Outright'" *New York Times Magazine*, 26 March 1961, 98.

10. Elma Udall phone interview, 8 April 2004; Udall, "Frost's 'Unique Gift Outright,'" 98; Jay Parini, *Robert Frost: A Life* (New York: Henry Holt, 1999), 413–14; Thompson and Winnick, *Robert Frost*, 481.

11. Elma Udall phone interview, 31 March 2004; author's recollections.

12. Udall, "Frost's 'Unique Gift Outright,'" 98; Thompson and Winnick, *Robert Frost*, 481–82; Parini, *Robert Frost: A Life*, 413; *Washington Post*, 21 January 1961; author's recollections. (In 1974, Stewart wrote, following a visit that he and Lee had with Louis Untermeyer, that Untermeyer believed, regarding "Frost's special verse written for JFK inaugural, 'It was a good thing he couldn't read it—it was the worst thing he ever wrote.' Lee commented, 'It was done on the spur of the moment. . .' [Further,] LU, referring to RF's tenuous stability, said 'He did all right when you consider he was from a crazy family,'" enclosed in an undated package from Udall to the author [received 5 April 2004].)

13. Udall, "Frost's 'Unique Gift Outright,'" 98; Udall parade photo sent to the author, 6 December 2002; Mitchell, "Robert Lee Frost"; *Washington Post*, 21 January 1961; author's recollections.

CHAPTER 4

1. Author's recollections and memorabilia.

2. Manning, "Secretary of Things," 38; Udall, "Frost's 'Unique Gift Outright,'" 98.

3. Udall interview, 17 November 2002; Udall to Robert F. Kennedy, 31 March 1961; Udall to Dean Rusk, 5 April 1961, with copies to other cabinet members, B 149, F 3.

4. Brendan Gill, *John F. Kennedy Center for the Performing Arts* (New York: Harry N. Abrams, 1981), 17; Kathleen Rasmussen, Office of the Historian, U.S. Department of State, e-mail to author, 16 January 2003.

5. Alfred C. Edwards to Udall, 17 April 1961, and Edwards to Boyd Finch, 17 April 1961, B 149, F 3; author's recollections and memorabilia. The keepsake had a fawn-color cover and glassine wrapper, and a format approximately 11½" × 7½". The title page states: DEDICATION / THE GIFT OUTRIGHT / THE INAUGURAL ADDRESS / WASHINGTON, D.C. / JANUARY THE TWENTIETH / 1961. Two versions of the keepsake exist, with different colophons at the end. Stewart Udall's copy states: "Eight hundred copies of this booklet have been made for those attending the reception given for Robert Frost by the members of the Cabinet of the United States. The edition was designed by Joseph Blumenthal and has been printed at The Spiral Press New York in April of 1961." A variant given to the author states: "This book has been made to celebrate an historic event. The edition consists of five hundred copies set in Emerson type and printed at The

Spiral Press, New York in March of 1961. The presidential eagle was cut in wood by Fritz Kredel especially for this publication. Typography by Joseph Blumenthal. This copy is number 171." My copy is inscribed: "To Boyd Finch, from, Robert Frost, with gratitude, Interior Department, May 2 1961."

6. Udall interview, 17 November 2002; author's recollections and memorabilia; "Kennedy Cabinet Invites Robert Frost to Recite," unidentified, undated clipping, B 149, F 3; Smith, "Robert Frost," 3.

7. Author's recollections.

8. William Stringer, "A Pause for Frost," *Christian Science Monitor*, n.d., clipping, B 149, F 2.

9. David Halberstam, "Udall, the Democrats' Art Lover, Is 'Hatchet Man' to Republicans," *New York Times*, 2 May 1961.

10. Robert Kennedy to Udall, undated, on Office of the Attorney General note paper, given the author on 17 November 2002.

11. Udall phone interview, 16 January 2003; Douglas Cater, "The Kennedy Look in the Arts," in *Horizon* 4, no. 1 (September 1961): 13; Betty Beale, "Udall Leading Capital's Culture Kick / Interior Secretary Host for 'Evenings,'" *New York World-Telegram and Sun*, 31 March 1962, B 149, F 2; Florence Berkman, "Udall Sparked March of Culture," *Hartford Times*, 19 June 1962, B 149, F 1.

CHAPTER 5

1. Author's recollections.

2. Berkman, "Udall Sparked March"; Leonard Bernstein to Udall, 27 March 1961, John O'Hara to Udall, 24 March 1961, Enrico Donati to Udall, 26 March 1961, and Jack Levine to Udall, 25 March 1961, all in B 88, F 18.

3. Carl Sandburg to Udall, 28 September, 7 October 1961, B 190, F 20; author's recollections and memorabilia.

4. "Boyd" (Finch) memo to Udall, 11 November 1961, B 149, F 4; Dorothy McCardle, "Sandburg's Words are Kind," *Washington Post*, 27 October 1961, B 149, F 4; Mary McGrory, "New Frontier Finds Friend in Sandburg," *Washington Evening Star*, 27 October 1961, both in B 149, F 4.

5. Letter, unsigned [Helga Sandburg], to Udall, 15 April 1964, B 190, F 20; author's recollections.

6. Udall oral history interview by William W. Moss for John F. Kennedy Library, Harvard, 12 January 1970, vol. 1, 165, transcript at the University of Arizona Library Special Collections, B 113 (no folder); Jim McGrath phone interview, 4 March 2003.

7. Udall to Robert F. Kennedy, 6 December 1961, and tabulation of the votes of fellow Cabinet members Dillon, Hodges, Goldberg, Day and McNamara, all in B 149, F 4.

8. Jean M. White, "Goldberg Becoming Unofficial Secretary of the Arts," *Washington Post*, 12 March 1962, clipping, B 149, F 2.

9. *Christian Science Monitor*, 27 March 1962, clipping, B 101, F 1; Meyers, *Robert Frost*, 318, 326–27, 329; photo of head table, B 149, F 1; Udall to author, enclosing Mark Van Doren, "Robert Frost at Eighty-Eight," typewritten remarks, copy with Udall notations, n.d., received 1 March 2003; *Washington Post*, 27 March 1962, clipping, B 101, F 1.

10. *Christian Science Monitor*, 27 March 1962, clipping, B 101, F 10; Udall, "Robert Frost and Washington," typewritten remarks, B 101, F 1; Udall to author, n.d., received 1 March 2003.

11. *Washington Post*, 27 March 1962, clipping, B 101, F 1; *Life*, 30 March 1962, cover, 60–69.

12. *Hartford Times*, 18 June 1962, B 149, F 1; Udall phone interview, 26 January 2004.

13. Udall phone interview, 26 January 2004; author's recollections.

14. Udall phone interview, 26 January 2004; Wilder to Udall, 30 November 1962, B 149, F 7; the "Cactus Joe" signature may have been a Wilder whim; at the time Wilder was residing temporarily in southern Arizona, in Nogales and Douglas.

Chapter 6

1. Udall, "Poetry, Stalinism, and the Cuban Missile Crisis," *Los Angeles Times Book Review*, 30 October 1988, clipping, no page number; Udall typewritten draft, "A Memoir of John F. Kennedy and Robert Frost," typescript, 3, 7–8, and Frost to Udall, 16 July 1962, copy, both given to the author 17 November 2002; Smith, "Robert Frost, Stewart Udall," 22–23.

2. Thompson and Winnick, *Robert Frost*, 492; Brian Madison Jones, "'A Serious Step Lightly Taken': Stewart Udall, Robert Frost, and the Trip to Russia," master's thesis, University of North Carolina at Greensboro, 1999, 15–17; F. D. Reeve, *Robert Frost in Russia* (Boston: Little Brown and Company, 1963), 15, 93, 104–16; Mitchell, "Robert Lee Frost."

3. Stewart L. Udall, *The Myths of August* (New York: Pantheon Books, 1994), 12–13; Reeve, *Robert Frost in Russia*, 110–16; drafts of Udall's essay, ". . . and miles to go before I sleep, Robert Frost's Last Adventure," B 208, F 5; Mitchell, "Robert Lee Frost."

4. Udall, "A Memoir," 8–10; Udall, "Poetry, Stalinism, and the Cuban Missile Crisis"; Udall interview, 17 November 2002; Loeffler-Lee Udall interview. Following the Bolshoi performance (at the Capitol Theater, primarily a movie venue), reviewer Richard Coe wrote in the *Washington Post:* "The need for the National Cultural Center … seldom has been as sharply dramatized as it was at the Bolshoi Ballet's opening [performance]." *Washington Post,* 16 November 1962.

5. Udall interview, 17 November 2002; Mitchell, "Robert Lee Frost."

6. Udall phone interview, 1 August 2003; "Book Week," 10, *Washington Post,* 30 August 1964, clipping, B 190, F 2; Mitchell, "Robert Lee Frost;" Udall draft article, B 208, F 5.

7. Udall phone interview, 1 August 2003.

8. Ibid.; Archibald MacLeish, *A Continuing Journey* (Boston: Houghton Mifflin, 1968), 301–3; Stewart L. Udall, "John F. Kennedy's Noblest Speech," partial draft given the author, 17 November 2002.

9. Udall phone interview, 1 August 2003; *New York Times,* 27 October 1963.

10. Edited draft for Kennedy. The "AS, jr." at the top of the draft suggests it was written by Arthur Schlesinger, Jr.

CHAPTER 7

1. Udall interview, 17 November 2002; *Hartford Times,* 27 March 1962, clipping, B 149, F 1.

2. *New York Herald-Tribune,* "Longhairs with Falsetto Voices? Bosh," clipping, 23 October 1961 enclosed with undated note "Louis U." to "The Secretary of the Interior;" *New York Times,* "MacLeish Sees Social Commitment in Poetry on the Rise," clipping, 5 September 1968, both clippings and note in B 190, F 24.

3. "Udall to Read Frost on Saturday," (Kensington Maryland) *Suburban Record,* clipping, n.d., B 118, F 1.

4. Udall to T. S. Eliot, 5 November 1962, copy, and Eliot to Udall, 12 November 1962, both B 149, F 1.

5. Copies in author's memorabilia.

6. *The Hollow Crown* program, author's memorabilia; author's recollections.

7. Author's recollections.

8. Udall to Robert McNamara, 5 August 1963, B 149, F 1; author's recollections and scrapbook; newspaper clipping (*Washington Post?*), 1 October 1963, B 242, scrapbook.

9. Gill, *John F. Kennedy Center,* 27–28.

10. Author's scrapbook and recollections.

CHAPTER 8

1. William V. Shannon, "Out West, Too, First Families Lean Toward Public Service," *New York Post*, 8 December 1960, B 242, scrapbook; Henry Romney to Udall, 21 January 1961, 24 March 1981, and Paul Horgan to Udall, 24 November 1961, B 88, F 10 and F 11.

2. Gary S. Messinger, "The Stegner Story," *Stanford Magazine* (May–June 1997): 57–58.

3. Alvin M. Josephy, Jr., *A Walk toward Oregon* (New York: Alfred A. Knopf, 2000), 280–81; author's recollections; Cater, "The Kennedy Look," 13.

4. Smith, "Robert Frost, Stewart Udall," 14; "Stewart and Lee" to "Robert" (handwritten), dated "Tuesday" (ca. 1961), given to the author, 17 November 2002; Stegner memorandum to Udall, "Proposed Robert Frost shrine at Ripton, Vermont," 20 October 1961, B 149, F 9. Jackson J. Benson, *Wallace Stegner: His Life and Work* (New York: Viking Penguin, 1996), 276; Messinger, "The Stegner Story," 57, 82.

5. Stegner memoranda to Udall, 20 and 26 October 1961, B 149, F 9 and F 21.

6. Udall tribute to Stegner at Western History Association conference, Albuquerque, N.M., 22 October 1994, recorded in notes by the author, who was present. The author's notes and Jackson J. Benson's account in his *Wallace Stegner*, 278–79, are in substantial agreement.

7. Author's recollections; Benson, *Wallace Stegner*, 278–79.

8. Sharon Francis to author, 16 February and 19 June 2003.

9. Ibid.; *Washington Post*, 12 May 1961; author's recollections.

10. Enclosed in an undated package from Udall to the author (received 5 April 2004).

11. Informal unsigned [Sharon Francis?] memorandum concerning *Quiet Crisis*, 23 February [1962], B 213, F 6; Harold Gilliam to Udall, "The Quiet Crisis," memorandum, 30 October 1962, B 213, F 2; Udall to author, 22 March 2003; author's recollections.

12. Author's recollections; Harold Gilliam to author, 15 June 2003; "Udall: Chief Architect of the New Conservation," *San Francisco Sunday Examiner and Chronicle*, 19 January 1969, clipping, B 218, scrapbook; Gilliam to Udall memorandum, "The Quiet Crisis," 1 November 1962, B 214, F 5.

13. Benson, *Wallace Stegner*, 279; Don Moser phone interview, 11 April 2003; author's recollections.

14. Gilliam to author, 15 June 2003; Gilliam, "Udall: Chief Architect of the New Conservation."

15. James Reston, Jr., phone interview, 19 March 2003.

16. Josephy, *A Walk toward Oregon*, 280–81.

17. Stegner to Udall, 25 August 1962, B 213, F 1, 7 June 1963, B 215, F 2, 15 June 1963, B 216, F 9.

18. Stewart L. Udall, *The Quiet Crisis* (New York: Holt, Rinehart and Winston, 1963), v, xi–xiii.

CHAPTER 9

1. Anonymous book jacket blurb, *Quiet Crisis*.

2. Josephy, *A Walk toward Oregon*, 280–81; Udall, phone interview, 6 September 2003. (The president's death changed my work. Secretary Udall had detailed me to the White House press office where I prepared briefing papers on natural resource and education issues, early preparations for the 1964 campaign. I also gathered information on regional issues for President Kennedy's travel briefings, including his November Texas trip, and I was privileged to attend his last Washington press conference. A few months later I again had a desk in the Executive Office Building for several weeks, continuing the same work for President Johnson's campaign.)

3. Menuhin to Udall, 16 December 1963, B 226, F 4; *Christian Science Monitor*, clipping, n.d., B 218, scrapbook; Stegner to Udall, 7 December 1963, B 190, F 21.

4. Clippings in B 218, scrapbook.

5. Author's recollections; Francis to author, 16 February 2003 and 19 June 2003; Richard J. Ewald with Adair D. Mulligan, edited by Sharon F. Francis, *Proud to Live Here* (Charlestown, N.H.: Connecticut River Joint Commissions, 2003).

6. Author's recollections.

CHAPTER 10

1. Mark Shields, "What Was Special About Kennedy?" clipping, n.d., no source, given the author by Udall, 17 November 2002; Udall, "On the Hill at Arlington," mailed to the author 2 December 2002.

2. "Frontiersmen (j.g.) Do They All Want to Be President?" *Newsweek*, 19 March 1962, 34–36; author's recollections and scrapbook.

3. Udall to Lady Bird Johnson, 3 January 1964, B 145, F 1.

4. Author's scrapbook and recollections.

5. Udall phone interview, 22 July 2003; Udall to Bill Moyers, 3 January 1964, B 209, F 9.

6. Roger L. Stevens to Udall, 6 February 1965, B 149, F 1; Udall phone interview, 1 August 2003; author's scrapbook.

7. "Tom 'n' Huck Stood 'Em Up," *Washington Post*, clipping, 25 January 1966, B 149, F 1.

8. Author's scrapbook and recollections; *Washington Post* and *Washington Evening Star*, clippings, both 19 April 1966, B 149, F 6.

9. Udall interview, 13 November 2004; author's scrapbook and recollections; Udall phone interview, 5 July 2003.

CHAPTER 11

1. Udall phone interview, 6 March 2003.

2. Leopold Stokowski to Udall, 27 November [19]64, B 119, F 11.

3. Udall to Jack Valenti, 11 October 1965, enclosing clipping from *Hudson Review*, 17, no. 3 (autumn 1965): 390, B 149, F 8.

4. Udall interview, 17 November 2002; author's recollections and scrapbook. In October 1968, Udall presided at ceremonies adding Sandburg's North Carolina home, "Connemara," to the National Park System.

5. John Gardner, introduction to Stewart L. Udall, *1976: Agenda for Tomorrow* (New York: Harcourt, Brace & World, 1968), xiv–xv.

6. Udall, *1976: Agenda*, vii–viii, 30–31, 129, 130–32.

7. John Graves, *Goodbye to a River* (New York: Alfred Knopf, 1960); Graves to author, 1 March 2003; author's memorabilia.

8. Graves to Udall, 15 February 1967, copy, B 207, F 7.

9. Udall's article appeared under a lengthy heading—almost a text in itself: "Our Perilous Population Implosion: Basic social problems may never be solved, warns the Secretary of the Interior, unless we create a new environment compatible with the human spirit. But time is short," *Saturday Review*, 2 September 1967, 13.

CHAPTER 12

1. John Ciardi's editorial comment accompanying Stewart L. Udall's "Once by the Pacific (1967)" *Saturday Review*, 11 May 1968, clipping, B 149, F 4.

2. Unidentified newspaper item, n.d., and handwritten draft on "Secretary of the Interior" note paper, signed "S", B 149, F 4.

CHAPTER 13

1. Cater, "The Kennedy Look," 13.

2. Udall, "Monumental Look at Washington," *New York Times Magazine*, 1 April 1962, 18.

3. Terry B. Morton, "The Threat, Rescue and Move," *Historic Preservation* (special double issue) 21, nos. 2/3 (April–June 1969 and July–September 1969): 101–8.

4. "Remarks of Secretary Udall [at Pope-Leighey House]. . . June 16, 1965," B 124, F 9.

5. Udall, "Why Not a Grand State Capitol for the Grand Canyon State?" *Arizona Republic*, 5 October 1969, B 207, F 3 and F 10; Stewart L. Udall, *1976: Agenda for Tomorrow*, 30–31.

6. Gill, *John F. Kennedy Center*, 27–28; Udall phone interview, 6 March 2003.

7. "First Lady Breaks Ground for Wolf Trap Center," *Washington Post*, clipping, 22 May 1968, B 145, F 1.

CHAPTER 14

1. Udall, phone interviews, 15 January, 1 August 2003; Udall to Mrs. John F. Kennedy, [re: "Son et Lumière"], 29 January 1962, B 190, F 11.

2. "U.S. Department of the Interior Events," B 142, F 2 and F 3; "Frankie Hewitt, 71, Force Behind Revival," *Washington Post*, n.d., clipping sent to the author by Udall, 6 March 2003; Associated Press news item, n.d., clipping, and *New York Times*, 31 January 1968, clipping, B 144, scrapbook.

3. U.S. Department of the Interior news release on the Internet, http://www .doi.gov/secretary/speeches.frankie.htm 28 April 2003.

4. "Department . . . Adopts New Official Seal," U.S. Department of the Interior news release, 6 March 1968, B 150, F 7; Wolf Von Eckhardt, "Where the Buffalo Roam," *Washington Post*, clipping, n.d., B 150, F 7.

5. "Barry" [Goldwater] to "Stew," 22 October 1968, enclosing text of Goldwater's remarks of 18 October 1968, B 150, F 7.

6. *Washington Post*, clipping, n.d., B 150, F 7; Udall phone interview, 17 October 2003.

CHAPTER 15

1. M. C. Seidel memorandum to "Mr. [E. C.] Burlew," 12 August 1939, copy, B 227, F 11; Dave Warren, phone interview, 20 March 2003; Department of the Interior news release, 13 March 1964, and *Washington Post*, 8 May 1964, clipping, B 227c, scrapbook.

2. Lee Udall, untitled short essay, n.d., 3–4, B 227, F 8.

3. Internet home page of the Institute of American Indian and Alaska Native Arts Development (IAIA), "The Institute—Past, Present and Future," February 2002; Dave Warren phone interview, 20 March 2003; Loeffler-Lee Udall interview; Lee Udall, "Indian Art Comes of Age," (unpublished?) typescript, 1–4, B 227, F 8; *Washington Post*, 8 May 1964, clipping, B 227c, scrapbook.

4. Udall phone interview, 3 January 2003; Lee Udall, "Indian Art Comes of Age," 2; [Santa Fe] *Pasa Tiempo*, 17 May 1964, B 247, scrapbook; *Washington Post*, 8 May 1964, clipping, B 227c, scrapbook; Lee Udall, "Indian Art," 3; Roberta (Mrs. James) Officer, phone interview, 7 October 2003.

5. Udall package to author, 6 March 2003, including "Lee Udall Was a Champion," *Albuquerque Journal*, 27 December 2001, clipping of obituary; Roberta Officer phone interview, 7 October 2003.

6. Udall phone interview, 3 January 2003; Lloyd New, *The House of Martinez* (Santa Fe: IAIA, 1967), catalog, B 227c, scrapbook; *Powhage* (Santa Fe: IAIA, 1967), author's memorabilia.

7. *Three from Santa Fe*, (Santa Fe: Center for Arts of Indian America, 1968), catalog, author's memorabilia; web home page of "d'Illyria University, the University of the Mind," reproducing Vincent Price's *Chicago Tribune* column of 30 October 1966.

8. "Indians Become Diplomats through Embassy Art Work," *Arizona Republic*, 23 December 1964, clipping, B 227a, scrapbook; Jim McGrath, phone interview, 4 March 2003.

9. McGrath phone interview, 4 March 2003.

10. "Lee Udall Was a Champion," *Albuquerque Journal*, 27 December 2001, clipping of obituary.

11. "American Indian Performing Arts Exhibition, April 21 through May 28, 1965," performance program and exhibit catalog, author's memorabilia; author's recollections; "Sipapu," advertising folder, author's memorabilia; Joseph C. Hickerson, "Indian Dance Drama Opens in Chill Air," *Washington Evening News*, clipping, 2 June 1966; Udall package to author, 26 December 2003.

12. McGrath phone interview, 4 March 2003.

13. Clippings from *Washington Daily News*, 22 April 1965 and 27 May 1966; *Washington Post*, 22 April 1965 and 22 September 1965; *Washington Evening Star*, 28 May 1966, all in B 227c, scrapbook.

14. Louis Ballard, phone interview, 24 March 2003; Udall phone interview, 17 October 2003.

15. Udall phone interview, 17 October 2003; Houston program of Harkness Ballet, B 227c, scrapbook.

16. Undated, unidentified clipping about Blair House, B 227, F 1; assorted clippings about Lee's activities, B 227c, scrapbook; Udall package to author, 30 December 2003.

CHAPTER 16

1. *Arizona Daily Star*, clipping, 3 October 1969, in Stewart Udall biographical file, Arizona Historical Society-Tucson, cited hereafter as AHS-Tucson.

2. B 208, F 1–2, 5–8, 11–12.

3. Udall package received by the author, 5 April 2004, containing, among other items, a draft of "Robert Frost, Kennedy and Khrushchev. . . ." and "Bill" (William Meredith) to "Stewart," 17 January 1972.

4. "Udall on the Environment," announcement for the column, n.d., B 210, F 1; "Stewart L. Udall Career Chronology," 4, Internet posting http://dizzy.library/arizona.edu/branches/spc/sludall/career.htm, 21 April 2003; Udall, phone interview, 18 September 2003.

5. Udall, phone interview, 19 August 2003; Stewart L. Udall, *America's National Treasures: National Nature Monuments and Seashores* (Waukesha, Wis.: Country Beautiful, 1971); Stewart L. Udall, Charles Conconi, and David Osterhout, *The Energy Balloon* (New York: McGraw-Hill, 1974), 282–85.

6. "Stewart L. Udall Career Chronology," 8; Udall, *Myths of August*, xi.

7. Joe Wilson, phone interview, 9 September 2003; anon., *Lee Udall, A Remembrance*, 37; Roberta Officer phone interview, 7 October 2003.

8. Wilson phone interview, 9 September 2003.

9. Joe Wilson and Lee Udall, *Folk Festivals: A Handbook for Organization and Management* (Knoxville: University of Tennessee Press, 1982), 12–14.

10. Wilson phone interview, 9 September 2003; James Griffith, interview, 17 November 2003.

11. Udall phone interview, 17 October 2003.

CHAPTER 17

1. Udall phone interview, 17 October 2003.

2. Anon., *Lee Udall, A Remembrance*, 26.

3. Stewart L. Udall, *To the Inland Empire: Coronado and Our Spanish Legacy* (Garden City, N.Y.: Doubleday, 1987), 3–7, rear jacket; Stewart Udall biographical file, AHS-Tucson.

4. Udall phone interview, 22 July 2004.

5. Stewart L. Udall, *The Quiet Crisis and the Next Generation* (Salt Lake City: Peregrine Smith Books, 1988).

6. James Bishop, Jr., "Prophet without Honor in His Land," *Arizona Republic*, 23 July 1989, clipping in biographic file, AHS-Tucson.

7. Udall interview, 17 November 2002.

8. Udall phone interview, 20 July 2004.

9. Paul Horgan to Udall, 28 July 1969; Udall to Horgan, 6 August 1969; author's recollections; Udall phone interview, 5 July 2003. (Interestingly, Udall learned early in his term that the portrait of Secretary of the Interior Albert B. Fall from New Mexico, goat of the 1920s Teapot Dome scandal, was sequestered in a back office. Stewart ordered Fall's portrait hung in the entrance hall to the secretarial suite, along with those of some other former secretaries.)

10. Jim McGrath phone interview, 4 March 2003.

11. Ibid.; Jack Loeffler phone interviews, 17 June and 8 December 2003.

12. Loeffler phone interview, 8 December 2003.

13. Jack Loeffler, *Adventures with Ed, A Portrait of Abbey* (Albuquerque: University of New Mexico Press, 2002), 159; Loeffler phone interview, 17 June 2003.

14. Loeffler phone interview 17 June 2003; Udall phone interview, 18 September 2003.

15. Stewart L. Udall, William Kittredge, Patricia Limerick, Charles Wilkinson, and John Volkman, *Beyond the Mythic West* (Salt Lake City: Gibbs Smith, Peregrine Smith Books in association with the Western Governor's Association, 1990); James W. Helworth, *Stealing Glances: Three Interviews with Wallace Stegner* (Albuquerque: University of New Mexico Press, 1998), 39; Udall phone interview, 17 October 2003.

16. A. Dan Tarlock, "The *Quiet Crisis* Revisited," *Arizona Law Review* 34 (summer 1992): 294–96, 299.

17. Stewart L. Udall, *In Coronado's Footsteps* (Tucson: Southwest Parks and Monuments Association, 1991); Stewart L. Udall and Randy Udall, *Arizona, Wild and Free* (Phoenix: Arizona Highways, 1993); Stewart L. Udall with James R. [Randy] Udall and David Muench, *National Parks of America* (Portland, Ore.: Graphic Arts Center Publishing, 1993).

18. Kathleen Shull, "Stewart Udall Reflects on the Mistakes of This Century," [University of Arizona] *Wildcat Online News*, 15 November 1999, wildcat.arizona. edu/papers; Udall, *Quiet Crisis*, 174, 179; Francis to author, 16 February 2003; Udall, *Myths of August*, xi.

19. Udall, *Myths of August*, 4–7, 17, 229; Udall phone interview, 18 September 2003.

CHAPTER 18

1. Loeffler phone interview, 8 December 2003; Udall phone interview, 18 September 2003.

2. Udall to author, enclosing "The Undaunted Hospice Patient," 19 September 2003.

3. Wilson phone interview, 9 September 2003; Robert ("Tree") Cody, "Love Song for Lee," *Siyotanka: Courting Flute of the Northern Plains* (Cracker Barrel Country Store—"Heritage Music Collection," 2002), Wilson, *Siyotanka* jacket.

4. Jay Udall, "Mother" in unpaginated memorial keepsake, *A Celebration of Life*, 2002.

5. N. Scott Momaday, "A Prayer for Lee Udall," in *A Celebration of Life*.

6. Udall note dated 30 May 1989, B 221, F 8; Udall, telephone interview, 7 October 2003. Polly and I never discussed it directly with Stewart, but we sense that it was Lee's reluctance that delayed his decision to assist in compiling this record of the Udalls and the arts.

7. Obituary for Lee Udall, "On the Wind—Passages," *Native Peoples Magazine* 15, no. 3 (March/April 2002), on the Internet, http://nativepeoples.com//np_ma02_apr02; Jack Loeffler telephone interview, 17 June 2003; Internet home page of the Institute of American Indian and Alaska Native Arts Development (IAIA), "The Institute—Past, Present and Future," February 2002.

8. Lloyd Kiva New in *Lee Udall, A Remembrance*, 25.

9. Telephone interviews with James McGrath, 4 March 2003; Louis Ballard, 24 March 2003; and Dave Warren, 20 March 2003.

10. Nick Spitzer, Public Sector Folklore, in *Lee Udall, A Remembrance*, 24.

11. Connie Cone Sexton, "Lee Udall, Dignified, Dedicated, and Playful," *Arizona Republic*, undated clipping, in *Lee Udall, A Remembrance*, 37.

CHAPTER 19

1. Udall telephone interview, 5 December 2003; Stewart L. Udall, *Forgotten Founders—Rethinking the History of the Old West* (Washington, D.C.: Island Press, 2002).

2. Tarlock, "The *Quiet Crisis* Revisited," 294–96, 299, a copy with Udall's inscription is in our memorabilia. Beginning in 1883, William F. Cody's big outdoor exhibition, "Buffalo Bill's Wild West," traveled through North America and Europe for thirty years, time enough to thoroughly establish the name and the image.

3. "Arizona Gets Credit," *Arizona Daily Star*, 2 October 1961; author's notes on Udall remarks at Western History Association conference, Albuquerque, 22 October 1994.

4. *Tucson Citizen*, clipping, 20 January 1961, and (Flagstaff) *Arizona Sun*, clipping, 18 January 1961, both in B 87 F 3. The *Arizona Sun* article found that the "Mountain Men" attracted interest in the capital even before their parade appearance.

5. Udall, *Quiet Crisis*, 32–37, 68, 74.

6. Udall, *Forgotten Founders*, xxvii, 7–9, 80–84, 90, 109–15.

7. Ibid., 146, 160, 195.

8. Author's recollections.

9. Udall, *Forgotten Founders*, 90, 146.

10. Ibid., 63–73. Two recent studies of the Mountain Meadows Massacre are Will Bagley, *Blood of the Prophets: Brigham Young and the Massacre at Mountain Meadows* (Norman: University of Oklahoma Press, 2002); and Sally Denton, *American Massacre: The Tragedy at Mountain Meadows, 1857* (New York: Alfred A. Knopf, 2003).

11. *Forgotten Founders*, 65–67, 70–76.

12. Udall, "A Testament: Compiled on the Completion of a War," B 226, F 4.

CHAPTER 20

1. "The Kennedy Look in the Arts," *Horizon* 4, no. 1 (September 1961): 13; Beale, "Udall Leading Capital's Culture Kick. . . ." *New York World-Telegram and Sun*, 31 March 1962, B 149, F 2; Berkman, "Udall Sparked March of Culture. . . ." *Hartford Times*, 19 June 1962, B 149, F 1; Stewart L. Udall, "The Arts as a National Resource," *Saturday Review*, 28 March 1964, 15.

2. Department of the Interior news release, "Commencement Address by Stewart L. Udall . . . at Dartmouth College, Hanover, New Hampshire, June 13, 1965," enclosed in package sent the author by Udall 30 December 2003.

3. Stegner to Udall, 21 April 1968, B 190, F 21.

4. Francis to author, 16 February and 19 June 2003; Reston, telephone interview, 19 March 2003.

5. Loeffler, telephone interview, 17 June 2003.

6. *Washington Evening Star*, clipping, n.d., B 227c, scrapbook; *Arizona Daily Star*, 13 July 1964; David M. Emmons, "Removing the Barnacles" foreword to Udall, *Forgotten Founders*, xxi.

7. Archibald MacLeish to Udall, 2 July 1965, in package from Udall received by the author 3 January 2003.

8. Untermeyer, *Bygones*, 218; Louis and Bryna Untermeyer to Udall, 8 February 1969, B 190, F 24.

9. Kay Halle to Eric F. Goldman, 14 March 1974, copy, and Kay Morrison to Udall, n.d., both in B 87, F 2; Emmons, "Removing the Barnacles" foreword to Udall, *Forgotten Founders*, xii.

10. Frost to Udall, 5 April 1961, in Smith, "Robert Frost, Stewart Udall and the 'Last Go-Down,'" 3.

Acknowledgments

Many persons helped with this project, and I am grateful to each of them. Without Stewart Udall's cooperation, of course, little could have been accomplished; he has entered into this project enthusiastically. He and Polly and I worked around our old-age health difficulties with phone interviews, letters providing answers to my questions, and in-person sessions on three occasions when Stewart visited in Tucson. Over a period of three and one-half years, envelopes containing more documents and photographs kept dribbling in from the Udall home in Santa Fe. Stewart's sister Elma of Albuquerque ("the historian of the family," he says), offered choice details relating to Robert Frost and the Udalls during the week of the Kennedy inauguration.

As she has with all my writing, Polly Hagan Finch, my wife, offered patient, thoughtful advice. As the resident specialist on *The Chicago Manual of Style*, she devoted many hours to copyreading the many versions of this work. She is invaluable to me.

In Santa Fe, Jim McGrath and Jack Loeffler were generous with their memories, and Indian Arts Institute faculty veterans Louis Ballard and Dave Warren also helped recall Lee Udall's influence. Joe Wilson told of Lee's effectiveness with the National Council for the Traditional Arts.

Among the few surviving members of Udall's Interior staff whom I located, Sharon Francis was exceedingly helpful with a detailed recollection of her years with Stewart. Texan John Graves generously provided useful memories of his service with Udall as did former Udall writing assistants Harold Gilliam, Don Moser, and James Reston, Jr. Wallace Stegner's son, Page Stegner, put me in contact with his mother, whose secretary, JoAnn Sloan Rogers, sent

a rare photo of Stegner and Udall in the field. Brian Madison Jones shared his thesis on Frost in Russia.

Stewart's earlier initiative in placing many papers, photographs, and scrapbooks with Special Collections at the University of Arizona Library provided a documentary foundation, and the library staff was always obliging. I offer special thanks to Jan Davis and archivist Roger Myers, who displayed a personal interest in this work. Thanks also to librarian Linda Gutierrez at the *Arizona Daily Star*.

Thanks are due to Kathleen Rasmussen of the Office of the Historian, U.S. Department of State, for a detail about the department's auditorium, and to Deputy Secretary of the Interior Lynn Scarlett, Robert Lamb of her staff, and Office of the Secretary photographer Tami A. Heilmann for a photo of the official Udall portrait.

Two of our closest Tucson friends, David Laird, former University of Arizona library director and southwestern book specialist, and Bruce Dinges, director of publications for the Arizona Historical Society and editor par excellence, offered many helpful comments as the work proceeded. Two other Tucson friends, Jim Griffith and Jennifer Jenkins, helped with some Arizona details.

It was my good fortune several years ago to have met Chuck Rankin, editor-in-chief at the University of Oklahoma Press, and his quick response to my rather tentative inquiry about "my Udall book" led to the work now in your hands. I also appreciate the contributions made by many persons in the publishing process: copy editor Jack Rummel, indexer Dawn Santiago, and book designer Bill Benoit. Many staffers at OU Press, led by Emmy Ezzell, Connie Arnold, and Anna Maria Rodriguez, production; Dale Bennie, Christi Madden, and Crystal Yoesting, sales and marketing; and Sandy See, publicity, provided their expertise, for which I am grateful. And I thank Special Projects Editor Alice Stanton, who, indeed, made this a Special Project.

Index